POSTCARD HISTORY SERIES

Columbus, Ohio

1898–1950

IN VINTAGE POSTCARDS

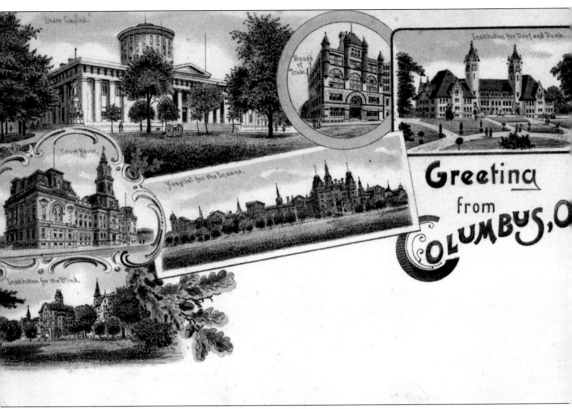

PRIVATE MAILING POSTCARD. The oldest picture postcards of Columbus were printed in 1898. Because the Federal government had not yet approved the use of the term "postcard" for these cards (as opposed to the pre-stamped postal cards printed by the government), they were labeled "private mailing cards." With two exceptions (the postcard shown above and the one shown on page 73), private mailing cards from Columbus are quite difficult to find.

POSTCARD HISTORY SERIES

Columbus, Ohio

1898–1950

IN VINTAGE POSTCARDS

Richard E. Barrett

ARCADIA
PUBLISHING

Published by Arcadia Publishing
Charleston, South Carolina

Printed in the United States of America

Library of Congress Catalog Card Number: 2002109585

For all general information contact Arcadia Publishing at:
Telephone 843-853-2070
Fax 843-853-0044
E-mail sales@arcadiapublishing.com
For customer service and orders:
Toll-Free 1-888-313-2665

Visit us on the Internet at www.arcadiapublishing.com

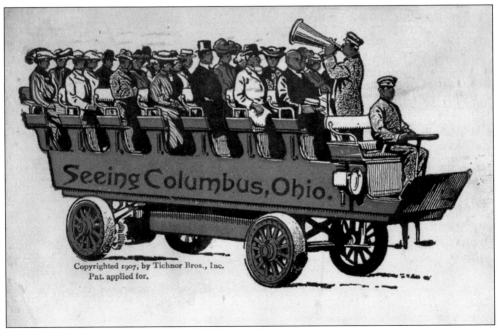

TOURING COLUMBUS. This 1907 postcard promotes seeing the sights in Columbus. It is a double-size, folded postcard with a strip of 24 small pictures of Columbus scenes folded accordion fashion and mounted inside. Many of the scenes are similar to postcard views shown in this book.

CONTENTS

ACKNOWLEDGMENTS

The author would like to acknowledge the help provided through the resources of the Biography, History and Travel Room of the Main Library of Columbus Metropolitan Library in obtaining dates and other details regarding many of the subjects presented in this book. Especially helpful was librarian Sam Roshon, a recognized resource on local history.

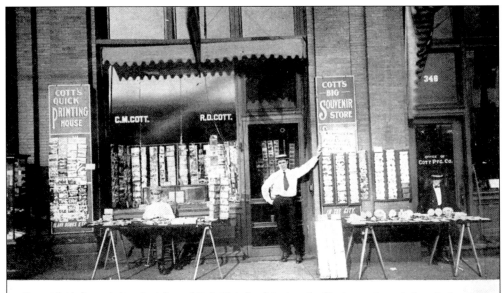

View of Cott's Souvenir Post Card Store, 348 N. High St., Columbus. O. The largest Souvenir Store in the city.

COTT'S POSTCARD SHOP. This postcard shows Cott's Souvenir Post Card Store. The store was located at 348 N. High Street. This would place it in the façade of the Union Station, a great location for selling souvenirs to visitors arriving in Columbus by train. In addition to the souvenirs, the picture shows an advertisement for Cott's Quick Printing House. They printed postcards, among other items, and postcards identifying the Cott Printing Company can still be found. Such postcards date from 1910 and 1911.

INTRODUCTION

At the turn of the century, photographs were not nearly as common in periodicals (magazines and newspapers) as they are today. Therefore, one of the ways of showing what an area looked like, or what was happening in an area, was through picture postcards. As periodicals increased the number of pictures in their publications, interest in postcards waned. However, the postcards that were published help to preserve images of scenes and events as they were before everyone had their own camera.

Columbus, Ohio: 1898-1950 in Vintage Postcards shows scenes from postcards during this period in which postcards were popular. It includes the earliest Columbus scenic postcards (1898), many scenes from the golden era of postcards (about 1905 to 1914), and later scenes that show some of the changes that occurred in Columbus between the end of World War I and the middle of the 20th century.

During the period covered by this book, Columbus grew from a population of 125,560 (1900) to a population of 375,901 (1950), a three-fold increase. Postcards were one vehicle for recording the activities that accompanied this growth

During the first half of the twentieth century, Columbus' major activities became centered around its being the state capital (government and state institutions), an education center (Ohio State University), a business center (especially banking and insurance), and the site for medium–size conventions and trade shows (requiring transportation, entertainment, and facilities for sleeping and eating). Family life involved homes, churches, schools, parks, clubs, and lodges.

Although Columbus did not develop as a major manufacturing center to the extent of other Ohio cites (such as Youngstown and Cleveland), it did have its share of interesting industries, especially in the area of vehicle manufacturing. At the turn of the century it had one of the largest buggy manufacturing plants in the country, turning out 1,500 buggies per month. Additionally, Columbus was home to a major manufacturer of firefighting vehicles (the Seagrave Company) and, in 1941, became home to a Curtiss-Wright airplane factory.

The material presented in this book is divided into sections that reflect the important segments of the Columbus community and the lives and activities of the persons living during that period. These sections include government facilities, downtown scenes and buildings, transportation, hotels and restaurants, family life, education, amusements and entertainment, hospitals and institutions, and manufacturing and business.

The material presented is from the personal collection of the author. He began collecting postcards of the greater Columbus area in 1971 and is considered to have the most extensive collection in existence—in excess of 6,000 postcards. His collection includes all of the common views and a large number of unusual or one-of-a-kind views, including the views of Papa

Presutti's first saloon and of Tommy Sopwith (the English airplane manufacturer) at an air meet in Columbus in 1910.

The author is a well-known local historian, having spoken many times on the subject, and also having prepared 39 newspaper articles, four previously published books, and twelve television programs on various aspects of Columbus history.

One

GOVERNMENT FACILITIES

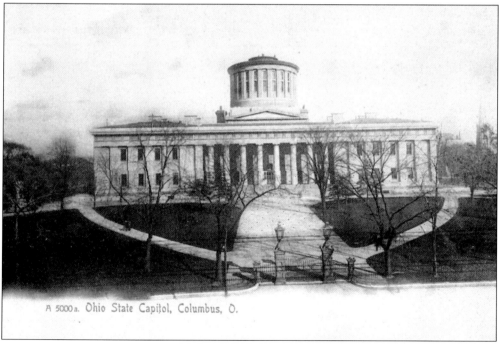

A 5000a. Ohio State Capitol, Columbus, O.

STATE CAPITOL, BEFORE 1906. Construction of Ohio's State Capitol building was begun in 1839. However, shortly thereafter there began a debate over whether Columbus should be the permanent state capital. Thus, construction lagged and the State Capitol was not completed until 1861. During most of the construction a 12-foot board fence surrounded the site as Ohio Penitentiary inmates were used in the construction. This postcard shows the State Capitol before the installation of the McKinley Monument in front of the building.

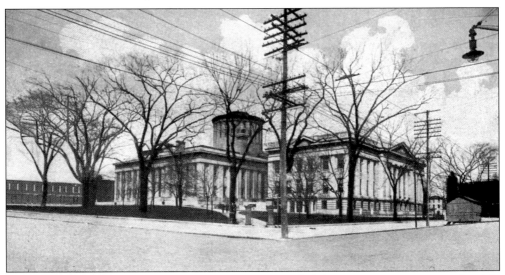

STATE CAPITOL ANNEX. The Judiciary Building, later called the State House Annex, in the right center of the picture was completed in 1901 to provide additional space for state offices. As shown, it was constructed immediately east of, or behind, the State House. Another interesting feature on this card is the voting booth at the extreme right. These polling places were shanties with steel wheels; they were pulled to the voting locations by tractors. Between elections they were stored on vacant lots. They were used in Columbus into the 1950s.

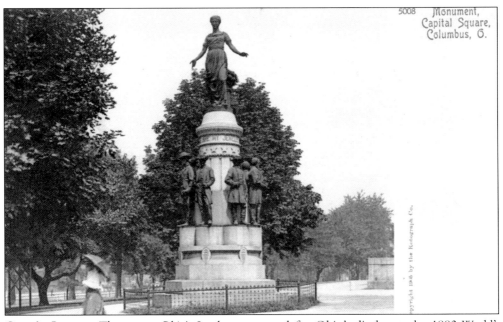

OHIO'S JEWELS. The statue *Ohio's Jewels* was created for Ohio's display at the 1893 World's Columbian Exposition in Chicago. The woman at the top represents Cornelia, who upon admiring a friend's gems was asked to exhibit her jewels. She left the room and returned with her two sons and exclaimed, "These are my jewels." Ulysses S. Grant, William T. Sherman, Philip Sheridan, Edward M. Stanton, James A. Garfield, Rutherford B. Hayes, and Salmon P. Chase are portrayed as Ohio's jewels. The statue was installed at the State Capitol in 1894.

10

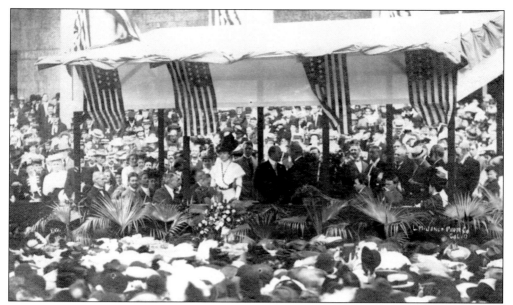

DEDICATION OF MCKINLEY MONUMENT. The McKinley Monument was dedicated on September 14, 1906, by Alice Roosevelt Longworth, the daughter of Theodore Roosevelt. She is the lady in white near the center of the picture. In another tribute to McKinley, in 1904 the Ohio General Assembly made the red carnation, McKinley's favorite flower, the state flower.

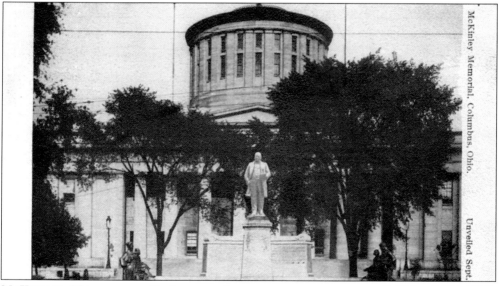

MCKINLEY MONUMENT. Having served two terms as governor of Ohio (1892-1896), William McKinley was elected President of the United States in 1896 and re-elected in 1900. He was fatally shot while at the Pan-American Exhibition in 1901 at Buffalo, New York. After his death, the McKinley Monument was erected in front of the State Capitol at the spot where he would turn to wave at his invalid wife in their Neil House hotel room as he walked to his office in the Capitol. The McKinley Monument was the work of artist Herman A. McNeil. At each end of the monument are groups of allegorical figures intended to typify American ideals and sentiments that underlie good government. Other figures typify peace and prosperity through progress.

11

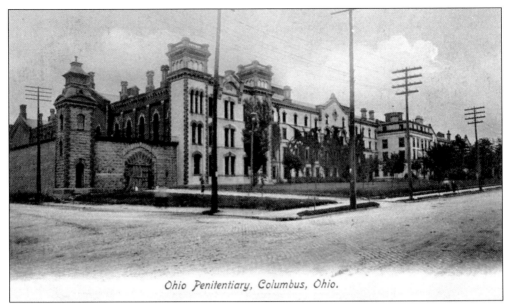

Ohio Penitentiary, Columbus, Ohio.

OHIO PEN, FRONT. The Ohio Penitentiary, the first part of which was completed in 1834, served as Ohio's major prison until 1972. This postcard shows the Ohio Pen after significant additions had been made in 1863 and 1879. The penitentiary was finally closed in 1984 and was torn down in 1996 to clear land for redevelopment, including the Nationwide Arena. This view is looking northeast from the intersection of Spring Street and Dennison (now Neil) Avenue.

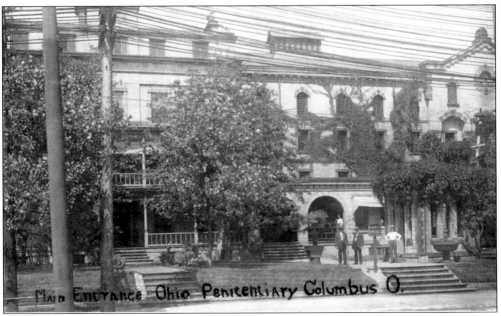

Main Entrance Ohio Penitentiary Columbus O.

OHIO PEN, ENTRANCE. From its earliest days through at least the 1930s the entrance of the Ohio Penitentiary was landscaped. The landscaping was maintained by prisoners. As shown on this postcard, during the first decades of the twentieth century the landscaping included a fountain. The man to the right (without a jacket) appears to be selling souvenirs, possibly postcards.

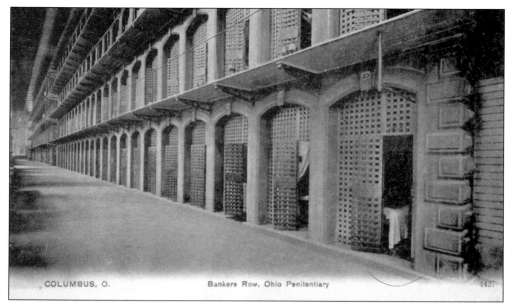

COLUMBUS, O. Bankers Row, Ohio Penitentiary 1127

OHIO PEN, CELLS. The construction of the Ohio Penitentiary cellblocks was such that the building was built like a large open barn. The cellblocks were erected inside the "barn," but were separated from the building walls by a clear space to reduce the possibility of escape. Thus, the windows visible from the outside were not really windows of cells. The heavy masonry walls and small openings in the cell doors provided security, but not much opportunity for ventilation. Bankers Row refers to a cell area where prisoners with financial resources enjoyed what luxuries they could afford.

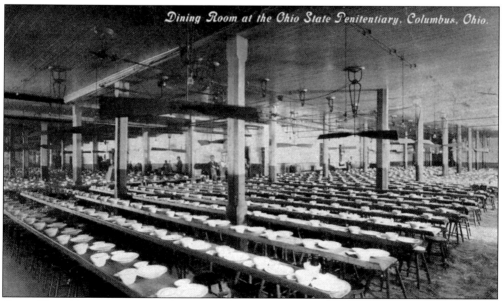

Dining Room at the Ohio State Penitentiary, Columbus, Ohio.

OHIO PEN, DINING ROOM. This postcard shows tables set in the dining room at the Ohio Penitentiary for the prisoners' meal. While prisoners were eating, they all had to face the same direction and they were not allowed to talk. Notice the large air fans that became popular, once again, when energy costs increased.

13

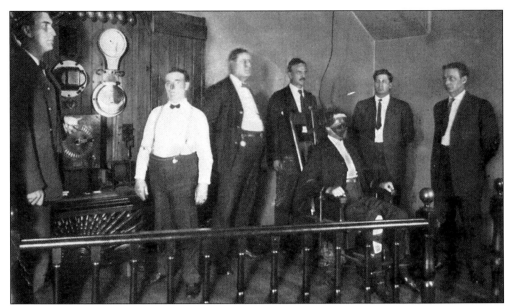

ELECTRIC CHAIR. The electric chair was installed at the Ohio Penitentiary in 1896. It was intended to provide a more humane form of execution, as hanging generally took from five to 28 minutes to bring about death. Ohio's electric chair was used 315 times, including three times on women. It was last used on March 15, 1963. In 1972 it was moved to the new penitentiary at Lucasville, Ohio, and in 2001 the state legislature prohibited its further use.

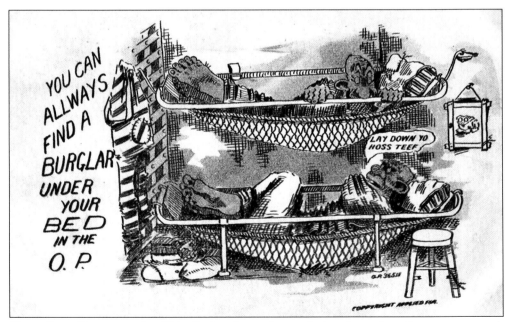

OHIO PEN, CARTOON. An Ohio Penitentiary prisoner designed a series of cartoon postcards that were sold at the souvenir shop at the end of penitentiary tours. Tours were popular, especially during state fair week, when visitors to Columbus would attend the fair and tour the penitentiary. Tours were discontinued during the 1950s. Numerous persons have told of touring the penitentiary as children with their school classes.

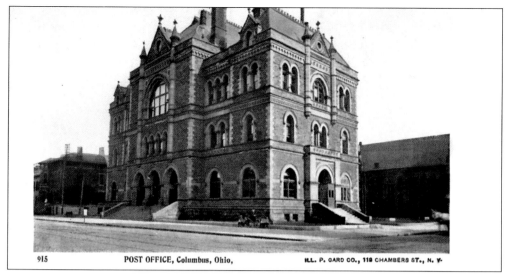

915 POST OFFICE, Columbus, Ohio, ILL. P. GARD CO., 119 CHAMBERS ST., N. Y.

ORIGINAL OLD POST OFFICE. Construction of what was known for many years as the "old post office" was begun in 1884 and completed in 1887. The building was to house all the Federal offices in Columbus, including "the United States District and Circuit courts, internal revenue and pension offices, post offices, and other government agencies." It was soon found not to have adequate space and it was closed in 1907 so that the building could be enlarged by extending it to the south. It was located on the southeast corner of State and Third Streets.

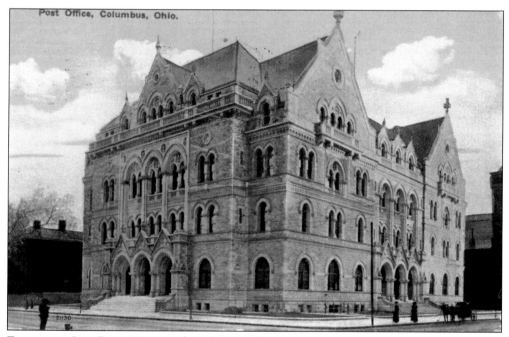

Post Office, Columbus, Ohio.

ENLARGED OLD POST OFFICE. The enlarged "old post office" was dedicated on January 31, 1912. It was nearly three times the size of the original building, and the renovation significantly changed the appearance of the building. Although a new main post office was opened in the Civic Center in 1934, this building remained a post office until 1974. After the last of the government offices moved out, the building was renovated and now serves as the Bricker & Eckler law offices.

15

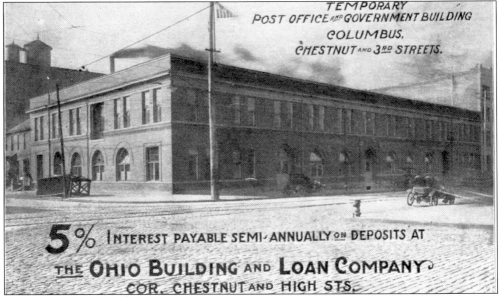

TEMPORARY POST OFFICE. While Columbus's main post office was being enlarged (1907–12), the post office and other government offices operated from this building on the southwest corner of Chestnut and Third Streets. The building later housed the Graybar Electric Co., and now is occupied by the Bernard Electric Supply Co. This postcard was distributed as advertising for the Ohio Building and Loan Company.

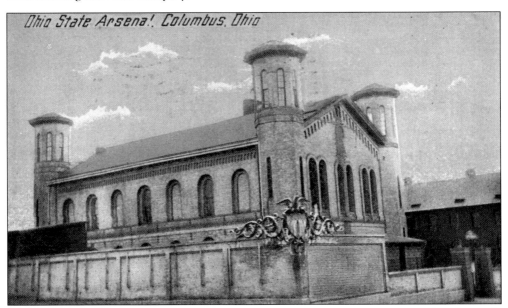

OHIO ARSENAL. The Ohio Arsenal was constructed in 1860. It is 100 feet long and 60 feet wide and its walls are 30 inches thick. The first floor housed a gun room and the armorer's shop and office. Small arms were stored on the second floor. In 1976 the arsenal was leased to the City of Columbus for use as a Cultural Arts Center. The eagle and shield on the corner of the wall was on the bow of the USS *Ohio* when it toured the world as part of Teddy Roosevelt's Great White Fleet in 1907–09. It is located at 139 W. Main Street.

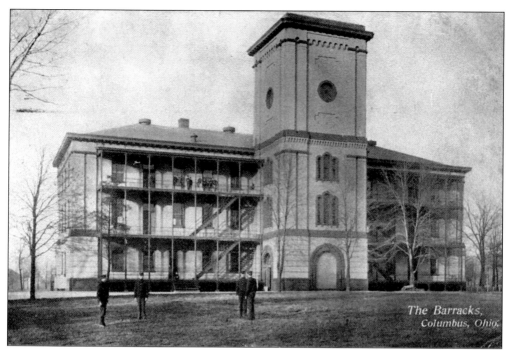

The Barracks,
Columbus, Ohio.

FORT HAYES, BARRACKS. The barracks and shot tower building was part of an Army facility in Columbus that was called the United States Arsenal Columbus Barracks when it opened in 1863. The shot tower was so named because it was once reported that, during Civil War days, molten lead was dropped from the top of the tower, forming round balls in the air. These reports are now known to be erroneous. In 1875 the facility became the Columbus Barracks and in 1922 it was renamed Ft. Hayes, in honor of Rutherford B. Hayes, Ohio governor and U.S. president. Abandoned by the Army, the Army Reserve and the Columbus Public Schools now utilize portions of the former base. It is located on the east side of Cleveland Avenue north of I-670.

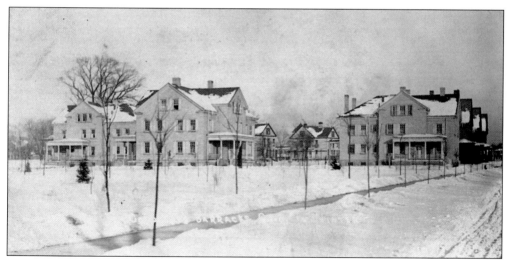

FORT HAYES, OFFICERS QUATERS. Officers quarters at the Columbus Barracks were more pleasant and spacious than the enlisted men's barracks. When the officers quarters were built, nearby residents objected to having the backs of the houses facing their properties.

17

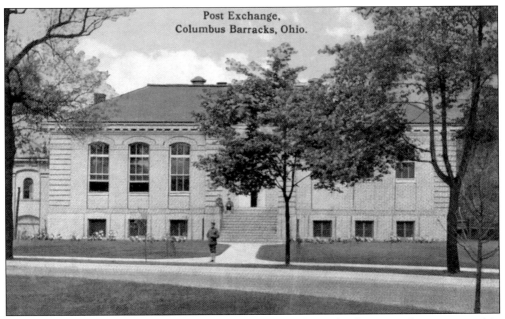

Post Exchange,
Columbus Barracks, Ohio.

FORT HAYES, POST EXCHANGE. A Post Exchange for the Columbus Barracks was opened in 1907. It included a restaurant, a well-equipped gymnasium, a pool and billiard room, bowling alleys, a well-stocked reading room, a store room, and a dance floor.

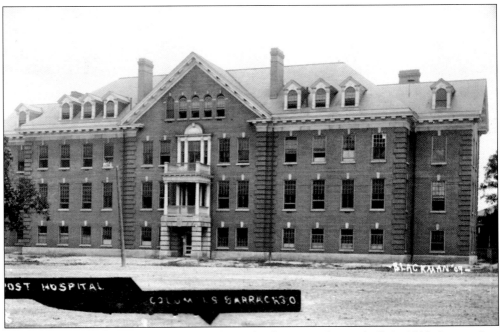

POST HOSPITAL.

COLUMBUS BARRACKS.O.

FORT HAYES, HOSPITAL. A hospital for the Columbus Barracks was built in 1908. At one time it was considered to be one of the best hospitals in Columbus.

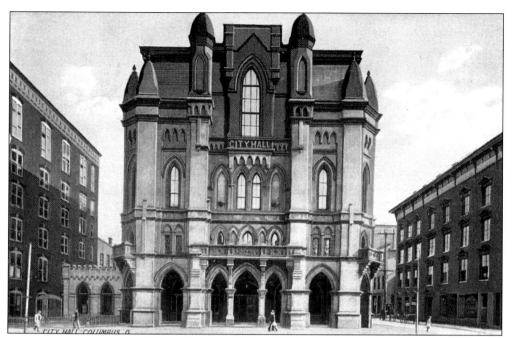

OLD CITY HALL. The old city hall, built in 1872, was Columbus's first building constructed for the exclusive use of the city government. (Earlier city offices were on the second floor of the Central Market House.) Upon opening, it was described as "one of the most beautiful and imposing public edifices that adorn the capital." However, by 1920 tastes had changed, and thus, when it was destroyed by fire in 1921, many persons did not consider it to be much of a loss. It was located at 39 E. State Street, the site of the present Ohio Theatre.

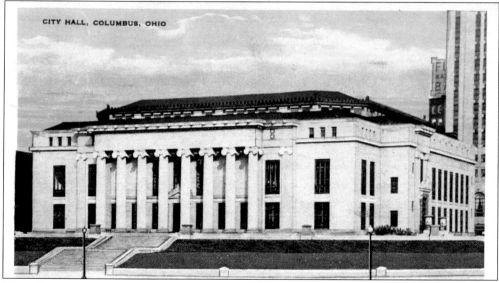

NEW CITY HALL. A new city hall was built in 1928. It was constructed along the Scioto River as part of a plan to house government offices in a Civic Center. Originally, the building was open on the east side, but in answer to the need for more office space an addition on that side in 1936 resulted in the building having an enclosed courtyard. Another addition was completed in 1949.

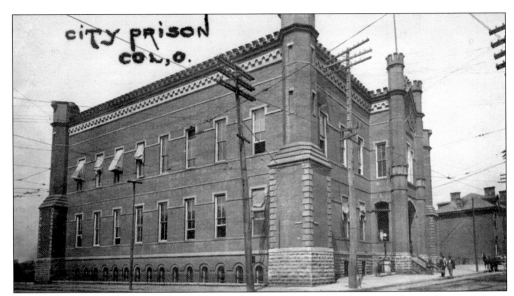

CITY PRISON. The city prison was placed in use on January 1, 1880; it was located at the corner of W. Town and Front Streets. An 1892 publication states that "Great was the rejoicing over the new prison by all classes, even the criminals classes, as the old quarters next to the Fourth street market, which was formerly known as the calaboose, was a miserable old den reeking with filth and alive with vermin, a menace to the health of any one who was compelled to enter its walls." The prison shown here was destroyed by fire in 1920.

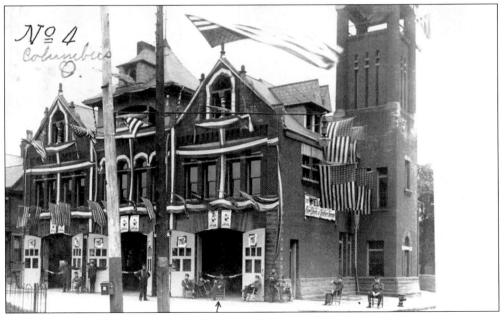

FIRE STATION NO. 4. Fire station No. 4 was located at 147 E. Russell St. It was one of seven fire stations built in Columbus in 1892. This postcard shows the fire station decorated with flags, bunting, and signs that say "Welcome Firemen." The picture was most likely taken during the 36th Convention of the International Association of Fire Engineers in Columbus in August 1908. It served as a fire station until 1945 and was later razed.

ENGINE HOUSE NO. 1. Engine House No. 1 was built at 89 N. Front Street in 1892. It served as both a fire station and as the headquarters for the Columbus fire department. The first floor contained equipment and stables; the second floor the firemen's dormitories and quarters for the captains; and the third floor the department offices, an assembly room, and the telegraph room. A tower in the rear was used to hang hoses while they dried. The building was used as a fire station until 1944 and was razed in 1954.

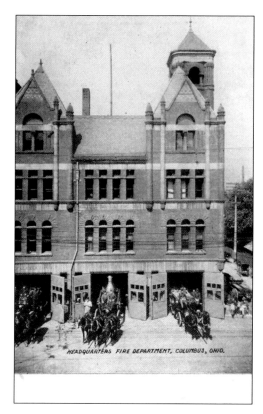

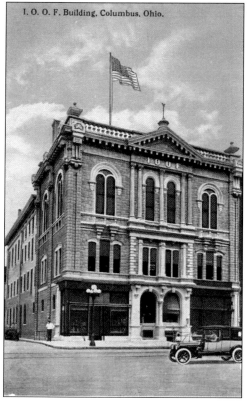

I. O. O. F. Building, Columbus, Ohio.

IOOF BUILDING. The Independent Order of Odd Fellows (IOOF) Temple was located on the southeast corner of S. High and Walnut Streets. It was constructed in 1870 and provided meeting space for seven IOOF lodges, the Silent Workers, the Knights of Pythias, and the Websterian Debating Club. Although not a government building, it is included here because it is most remembered for the fire that destroyed the building on February 19, 1936; fighting the fire in 10-degrees-below-zero temperature, five firemen were killed when a wall collapsed on them.

21

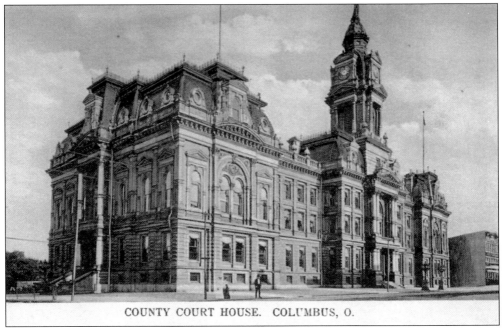

COUNTY COURT HOUSE. COLUMBUS, O.

FRANKLIN COUNTY COURT HOUSE. The need for a new Franklin County Courthouse was evident after a fire in the old courthouse destroyed many public records in 1879. Ground was broken for the new courthouse on July 4, 1885, and the building was dedicated on July 13, 1887. Located on the east side of High Street, between Fulton and Mound Streets, it served as county court house until it was razed in 1974.

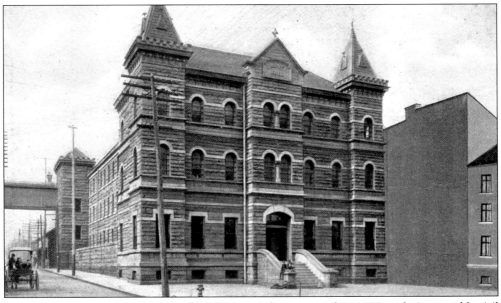

FRANKLIN COUNTY JAIL. The Franklin County Jail was opened in 1889, replacing an older jail that was constructed in 1865. The jail was located at 36 E. Fulton Street, behind the Franklin County Courthouse. A bridge linked the jail to the courthouse to ensure that prisoners could be moved securely between the buildings. The jail was closed and demolished in 1971.

Two

Downtown Scenes and Buildings

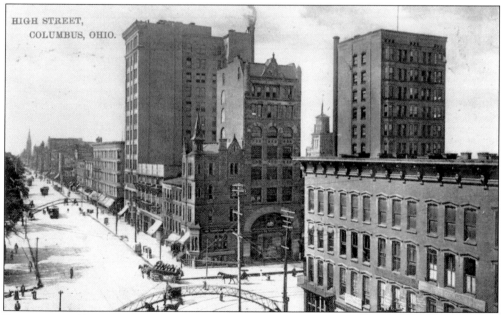

Broad and High, Toward Southwest. This postcard shows the intersection of Broad and High Streets, about 1907. The building on the corner is the first Huntington Bank building. To its right is the nine-story Wheeler Building, which was built in 1892–95 and was the tallest building in Columbus at the time. It was razed in 1975. Further to the right is the eleven-story Wyandotte Building, completed in 1897. To the left of the Huntington Bank building are the twelve-story Harrison Building and, further down High Street, the Neil House Hotel.

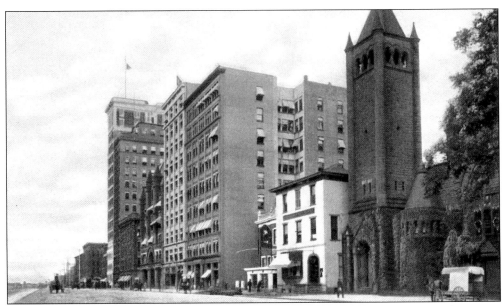

EAST BROAD STREET, LOOKING WEST FROM THIRD STREET. This view was looking west on Broad Street from Third Street. None of the buildings in the foreground of the picture shown on this postcard remain. The church is the First Congregational Church. To its left beyond the small buildings are the nine-story Outlook Building, the ten-story Spahr Building, and the Board of Trade Building, all of which have been razed. Further left, the Hayden-Clinton Bank Building, the Hayden Building, and the State Savings & Trust Building remain.

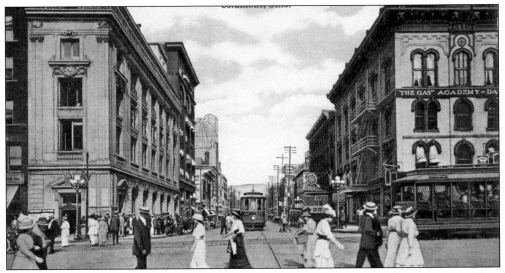

EAST GAY FROM HIGH STREET. This postcard shows a view looking east along Gay Street from High Street. The interesting thing about this view is the way the people are dressed. Presumably, the persons shown were either shopping (as all major stores were located in the downtown area) or worked downtown. The long dresses and hats on the women, and the suits and hats on the men, show what was considered to be acceptable dress when in the downtown area. As late as the early 1960s, female students at Capital University were taught to wear a hat and gloves when shopping at Columbus's downtown department stores.

24

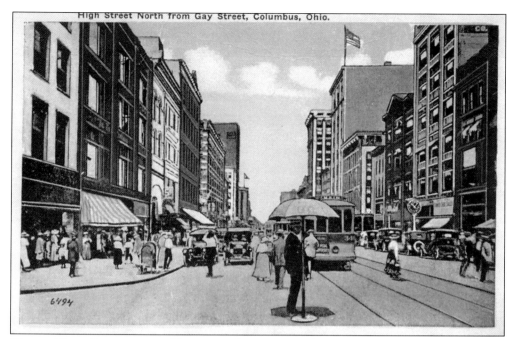

High Street North from Gay Street, Columbus, Ohio.

NORTH HIGH STREET WITH UMBRELLA POLICEMAN. This postcard shows the intersection of High and Gay Streets, about 1920. Traffic control was already becoming a problem; Columbus solved this problem by stationing policemen at busy intersections with umbrellas that had "GO" and "STOP" printed twice each on opposite sides. By rotating the umbrellas, the policemen could direct traffic. Columbus' first electric traffic signals were installed in November of 1924.

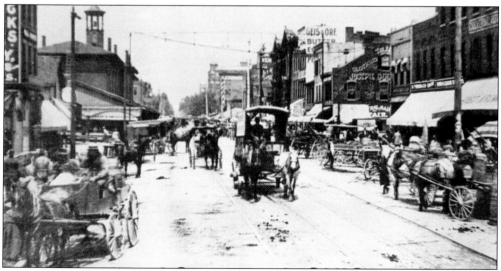

NORTH ON FOURTH STREET. This view is looking north on Fourth Street toward the intersection on Rich Street. The building on the left with the bell tower is the city-owned market house (or Central Market). When it was completed in 1850, city government offices and the city jail were located on the second floor. Besides the stalls on the inside and lining the outside of the market house, farmers lined the street with fresh produce to sell. The market house was razed in 1966 as part of the Market-Mohawk Redevelopment Project.

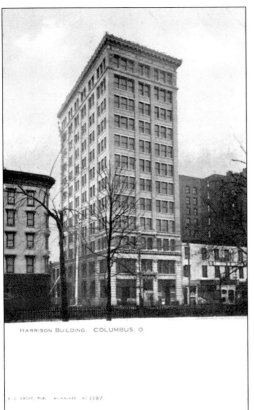

HARRISON BUILDING. COLUMBUS, O

HARRISON BUILDING. The Harrison Building was opened in 1903 at 21 S. High Street. The building was acquired by the Huntington Bank in 1915, and the bank's operations were moved there in 1916. The building was remodeled and incorporated into the larger Huntington Bank building, which opened in 1925.

HUNTINGTON BANK BUILDING. The Huntington Bank was established in 1866 on the southwest corner of Broad and High Streets. As the bank grew and needed more space, it first purchased the Harrison Building and then incorporated the existing building into a larger Huntington National Bank building that was completed in 1925.

THE HUNTINGTON NATIONAL BANK
of
COLUMBUS, OHIO

UNION BANK BUILDING. The Union National Bank Building was located on the southeast corner of Spring and High Streets. It opened in 1886 and was razed in 1945. At various times the building was known as the Merchants & Manufacturers Bank, the King Building, and the Hanover Block.

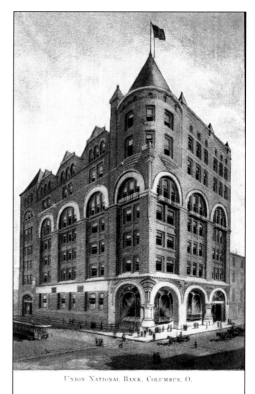

UNION NATIONAL BANK, COLUMBUS, O.

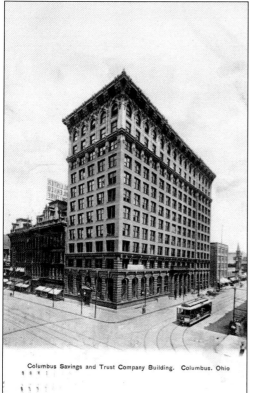

Columbus Savings and Trust Company Building. Columbus. Ohio

ATLAS BUILDING. The twelve-story Columbus Saving and Trust building, located on the northeast corner of High and Long Streets, was completed in 1905. It was later known as the Ohio Savings & Trust Building, and still later as the Atlas Building. The building remains in use.

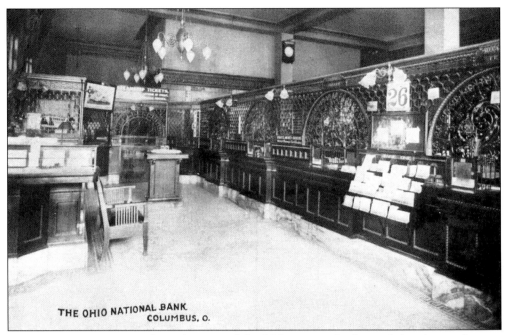

The image shows: THE OHIO NATIONAL BANK COLUMBUS, O.

BANK INTERIOR. During the early years of the 20th century, banks tended to be much more secure looking than at present. Tellers were located behind strong metal grills. This postcard shows the interior of the Ohio National Bank, about 1909. The bank was then located on the southeast corner of Main and High Streets.

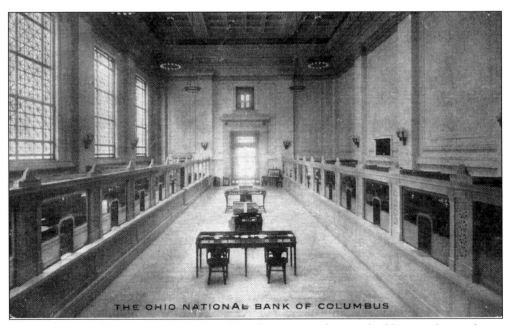

The image shows: THE OHIO NATIONAL BANK OF COLUMBUS

BANK INTERIOR. When the Ohio National Bank constructed a new building on the southwest corner of Town and High Streets in 1911, they utilized a more simple design for both the building exterior and the interior. The building remains in use today, but not as a bank.

WYANDOTTE BUILDING. The Wyandotte Building was designed by Daniel H. Burnham, the architect for the 1893 World's Columbian Exposition in Chicago. Construction began in 1894 and was completed in 1897. It was Columbus' first steel-framed skyscraper and is the only one remaining of Columbus's earliest skyscrapers. It is reported to have been a financial failure. After being threatened with demolition, it was renovated in 1979. It is located at 21 W. Broad Street.

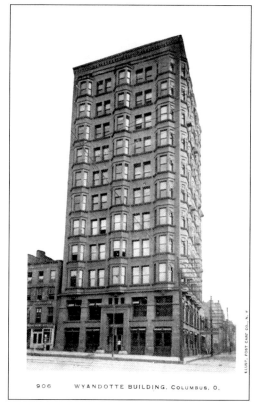

906 WYANDOTTE BUILDING, COLUMBUS, O.

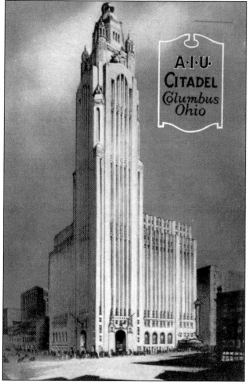

A·I·U· CITADEL Columbus Ohio

AIU CITADEL. Built as the American Insurance Union (AIU) Citadel, Columbus' first true skyscraper was completed in 1927. It is 555.5 feet tall (six inches taller than the Washington Monument in Washington, DC.). When constructed, lights on top were touted as a beacon to aviators for 75 miles. The AIU failed in 1933, and the building was purchased by L.L. LeVeque and John C. Lincoln in 1944. Renamed the LeVeque-Lincoln Tower, it remained Columbus' only skyscraper until the Columbus Plaza (currently the Adams Mark Hotel) was built in 1963. It is located at 50 W. Broad Street.

29

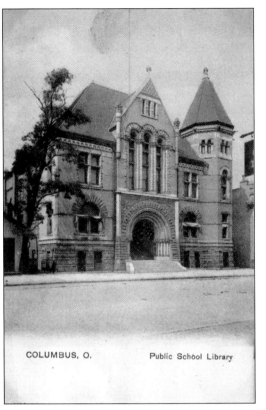

COLUMBUS, O. Public School Library

PUBLIC SCHOOL LIBRARY. This building was constructed as the Town Street Methodist Church in 1852. It was located on the northeast corner of the intersection of Town Street and Pearl Alley. A political convention held there in 1855 has been claimed as the birth of the Republican Party. When the church moved to a larger facility in 1891, the building was sold to the Columbus Board of Education and it became the public school library. The building was so damaged by a storm in 1911 that it was abandoned and torn down. Some postcards of this building are mislabeled, identifying this building as the Board of Trade building.

BOARD OF TRADE. The Columbus Board of Trade building was completed in 1889 at 30 E. Broad Street. During the construction, an arch that formed the ceiling of the basement collapsed when the supporting scaffolding was removed. Two men were killed and another seriously injured in this accident. The building was razed in 1969 to clear space for the Rhodes State Office Tower. In 1909 the Board of Trade became the Columbus Area Chamber of Commerce.

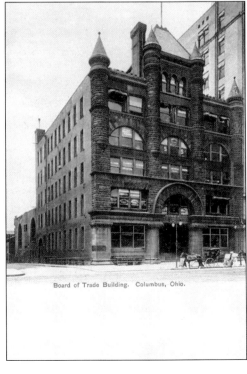

Board of Trade Building. Columbus, Ohio.

HAYDEN-CLINTON BANK. The Hayden-Clinton Bank building was built by Peter Hayden, a Columbus industrialist, in 1869. It is located in the heart of downtown Columbus at 20 E. Broad Street. While most other buildings of its age have been razed, the Hayden-Clinton Bank building continues to survive.

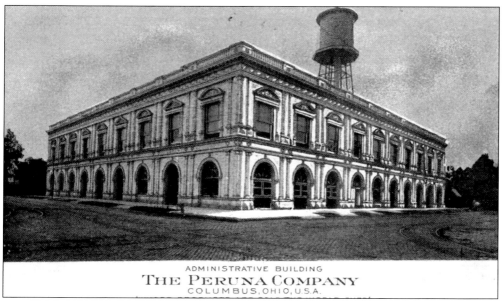

PERUNA BUILDING. The Peruna Building was the administration and manufacturing headquarters for Dr. Samuel B. Hartman's Peruna tonic. Peruna, sold through extensive advertising and the use of testimonials, was touted as a cure-all. Sales declined after 1906, when the Pure Food and Drug Act required disclosing that Peruna was about 30 percent alcohol. The building was nearly completed in 1904 when it was destroyed by a fire. Rebuilt, it opened in 1906 and served as Peruna's headquarters until 1929. Located at southeast corner of Third and Rich Streets, it was razed in 1973.

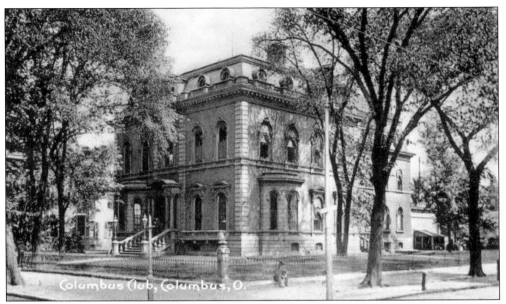

COLUMBUS CLUB. The house now occupied by the Columbus Club was erected about 1865 as a home for financier Benjamin E. Smith. He lost his fortune when he tried to establish a rival to Coney Island in New York. After serving as the Columbus home for two governors, it was purchased by the newly-formed Columbus Club in 1887 and has served as the home of the club since that time. It is located on the southeast corner of Broad and Fourth Streets.

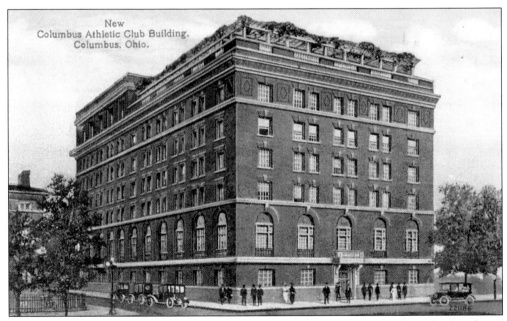

ATHLETIC CLUB. The Columbus Athletic Club was formed in 1912. Ground was broken for an Athletic Club building in 1914 and the facility opened on January 19, 1916. In its early years, athletics seem to have played a more prominent role in social and business contacts, much like golf does today. Special events included a diving exhibition by Mike Peppe and a wrestling match between Cora Livingston and Miss Grace Brady. The Athletic Club is located at 140 East Broad Street.

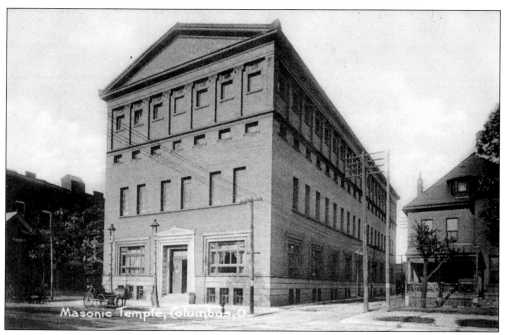

MASON TEMPLE, OLD. The original section of the Masonic Temple was completed in 1899. In 1906 the auditorium on the top floor was severely damaged by a fire.

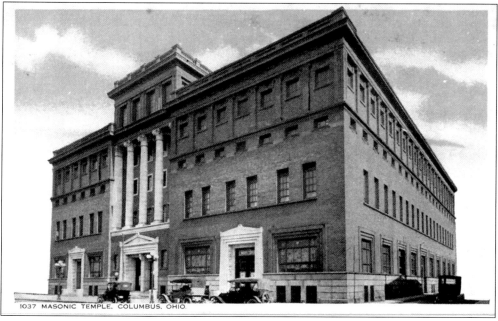

MASONIC TEMPLE, NEW. The Masonic Temple was enlarged to the structure shown here with additions in 1935. The original portion is to the right in this picture. After no longer being needed by the Masons, the building was sold and renovated in 1996–97; it now is the Columbus Athenaeum. It is located at 32 N. Fourth Street.

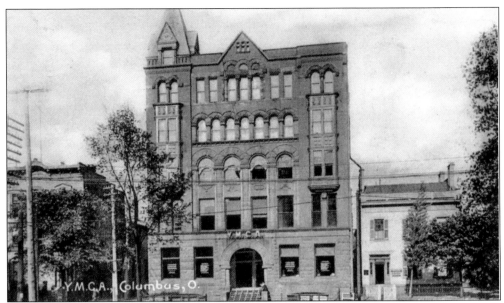

YMCA. The Columbus YMCA was housed in rented facilities from its founding in 1866 until it moved into this building at 34 S. Third Street in 1892. By 1916 it was determined that this building would be inadequate, and efforts were begun to build a new central YMCA building and an adequate structure for the colored branch. Preference was given to the colored branch and the cornerstone for it was laid in 1918. Finally, the new central YMCA building on the northwest corner of Front and Long Streets was opened in 1924. The Columbus Dispatch building now occupies the Third Street site.

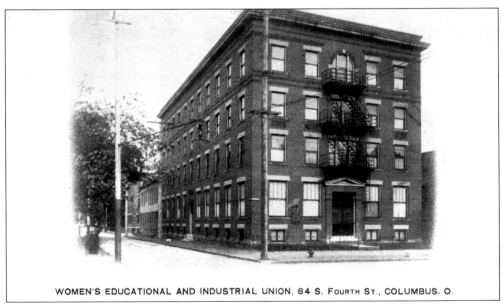

WOMEN'S EDUCATIONAL AND INDUSTRIAL UNION, 64 S. FOURTH ST., COLUMBUS. O.

YWCA. The Columbus branch of the Women's Educational and Industrial Union (WEIU) was founded in 1887. In 1902 the WEIU acquired a residence at 64 S. Fourth Street. By 1902 the residence was too small and it was razed and replaced with the Residence Hall shown here. The Columbus branch of the YWCA formed in 1894, and the WEIU and YWCA later merged.

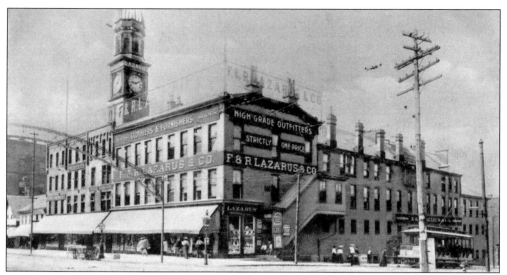

Lazarus, Old. The First Lazarus retail store opened in 1851 and grew into a major department store in Columbus. In 1895 a new front was installed on several older buildings on the southwest corner of Town and High Streets, and a tower was added to create the building shown on this postcard. Shortly thereafter, an electric power plant was installed and the Lazarus store became the most brightly lighted building in Columbus.

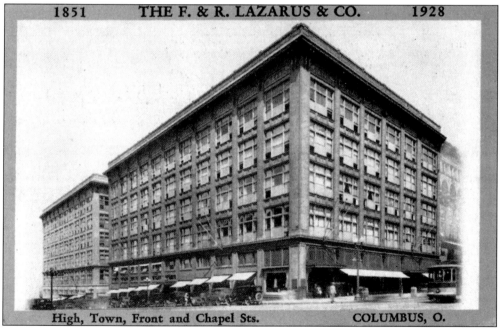

Lazarus, New. In 1909 Lazarus wanted to expand, so they constructed a new building on the northwest corner of Town and High Streets. The move to the new building was accomplished in one weekend. They closed for business at the end of the day on Saturday, wheeled all the merchandise across Town Street (which had been blocked off), and opened at the new location on Monday morning. The new store featured a moving stairway (escalator), an aviary, and an alligator tank (which was removed a year later).

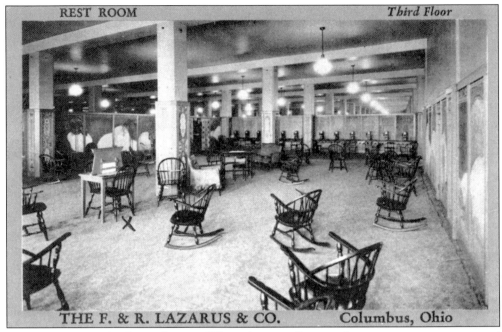

LAZARUS, WOMEN'S REST ROOM. When the new Lazarus department store was opened in 1909, the term "women's rest room" must have been taken literally. As can be seen on this postcard, it was equipped with rocking chairs and the atmosphere appears conducive to relaxing. The rear wall consists of a row of telephone booths.

HOME STORE. The Home Store was located across High Street from Lazarus, at 130–140 S. High Street. It was known both as the Home Store and as Morehouse-Martens, for Max Morehouse and C.R. Martens, the owners. The Home Store was destroyed by a fire in 1920. After being rebuilt, it was known primarily as Morehouse-Martens until merging with The Fashion, which had located across the alley, to form the Morehouse Fashion store. Later the building housed the Union and Halle's for short periods before being closed in 1982 and being destroyed by a fire in 1986.

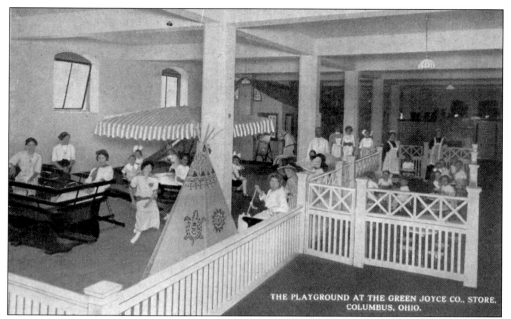

GREEN-JOYCE, PLAYGROUND. The Green-Joyce Company originally was a wholesale business. They later expanded into the retail business in a building on the southeast corner of High and Chestnuts Streets. In 1928 the business became the Wholesale Radio Company.

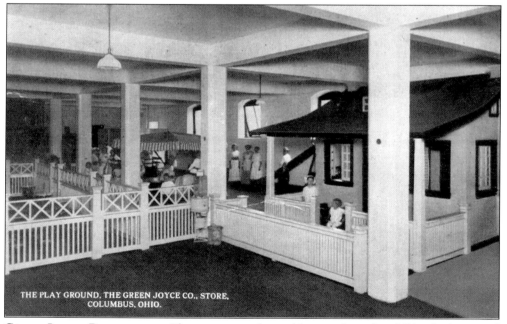

GREEN-JOYCE, PLAYGROUND. The two postcards on this page show the children's playground that the Green-Joyce retail store provided. Close examination of the postcards shows several women that appear to be dressed in nurse's uniforms and aprons, presumably to ensure the safety of the youngsters.

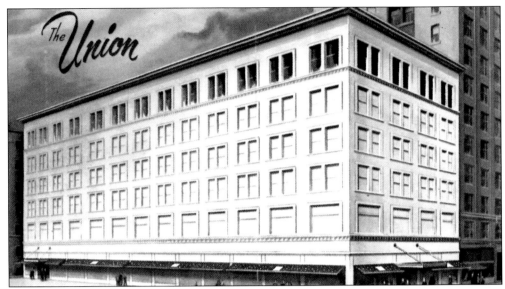

UNION STORE. The Union opened as a clothing store in 1895 on the northwest corner of Long and High Streets. After being destroyed by a fire in 1903, the Union was rebuilt and reopened in a four-story building in 1904. In 1909 the building was expanded by adding two floors to create the building shown on this postcard. This downtown Union store was closed about 1967.

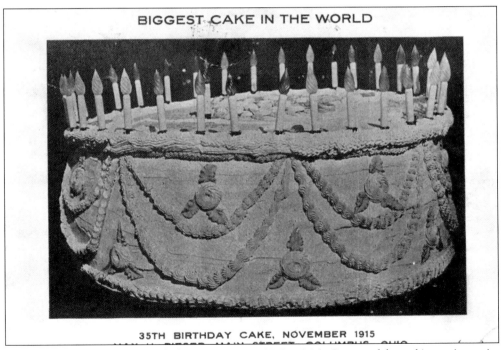

RIESER'S BIG CAKE. Rieser's clothing store, at 66–80 East Main Street, celebrated its anniversaries with gigantic cakes. The cake for their 35th anniversary, in November of 1915, was 4.5 feet in diameter and weighed nearly a half ton. It required a barrel of flour, a barrel of sugar, 1000 eggs, 3 tubs of butter, 50 quarts of milk, a quart each of lemon and vanilla flavoring, and 225 pounds of icing. Rieser's store was razed in 1927.

Three

TRANSPORTATION

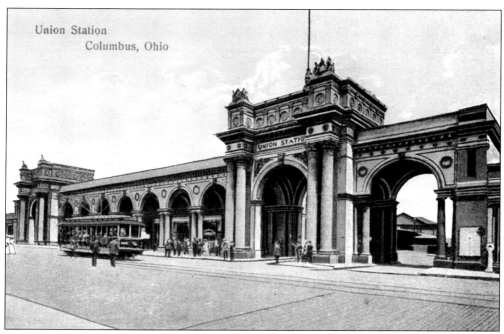

Union Station
Columbus, Ohio

UNION STATION. The Union Station was Columbus's primary railroad station from 1850 to 1972. This postcard shows the third Union Station (1897–1972). Designed by noted architect Daniel H. Burnham, it was razed in 1977. Actually, this postcard shows only the façade, which faced N. High Street (where the convention center now sits); the actual station building was about one block east of the façade and can be seen through the right-most arch. The right arch was removed about 1930 to permit easier automobile access to the station. The left arch was saved during the razing and now is located in the Arena District.

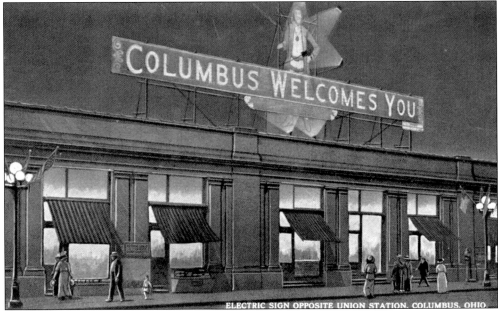

UNION STATION SIGN. For a time, visitors to Columbus arriving at the Union Station were greeted by this sign. It was mounted on a low row of buildings on the west side of High Street facing the Union Station facade. Everyone exiting the station would have seen this sign. A newcomer to Columbus once reported that when she saw this sign she knew that Columbus must be a friendly city. Today Columbus maintains a welcome sign on the road exiting Port Columbus.

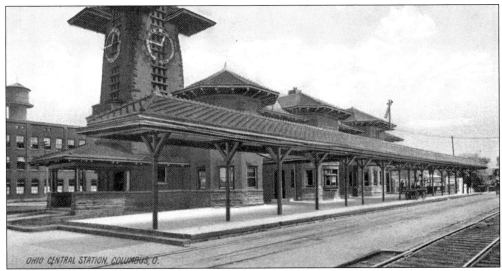

T&OC STATION. The Toledo & Ohio Central Railroad chose not to participate in the Union Station and instead built their own station at 379 W. Broad Street. Designed by Yost & Packard, it was completed in 1896. When first constructed, the railroad passed the station at grade level. However, to improve traffic flow to the west side of Columbus, the track was elevated in 1912. From that time until it closed in 1930, the train platform was at the second floor level of the station. The reason for the Oriental-style architecture is not known. The building is now occupied by the Volunteers of America.

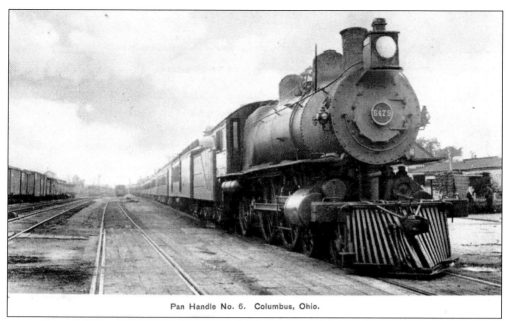

Pan Handle No. 6. Columbus, Ohio.

PANHANDLE TRAIN. The division of the Pennsylvania Railroad west of Pittsburgh was known as the Panhandle Division, because it passed through the panhandle of West Virginia. This postcard shows Panhandle passenger train No. 6 at Columbus. The train is being pulled by an Atlantic-type locomotive, which was used on fast passenger trains. The postcard dates to about 1908.

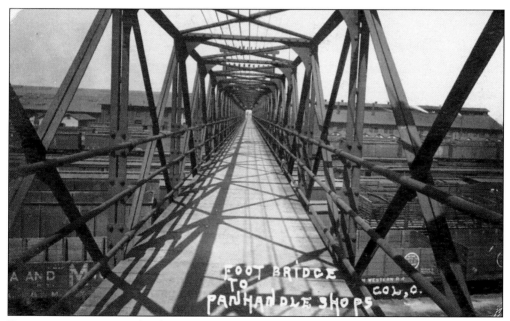

PANHANDLE YARDS. Columbus was the site of a major Panhandle Division yard. It was located north of Leonard Avenue between Cleveland and Joyce Avenues. The south part of the yard had 27 parallel railroad tracks and much rail traffic. Because crossing all these tracks would impose a danger, a pedestrian bridge was constructed across this portion of the yard from north to south. This postcard shows a view along the bridge.

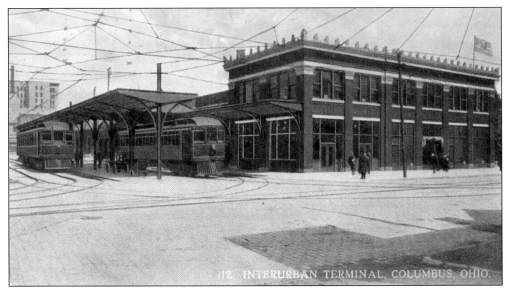

INTERURBAN STATION. When interurban electric rail service was introduced to Columbus in 1891, each interurban line had its own terminal. This was an inconvenience for persons wanting to transfer from one line to another. In 1912 nearly all the interurban lines joined together to build an interurban station from which they all would operate. This interurban station, which is shown above, was completed in 1912 and served until interurban service was discontinued in 1938. The building later served as an A&P grocery store before being razed in 1967. It was located on the northwest corner of Rich and Third Streets.

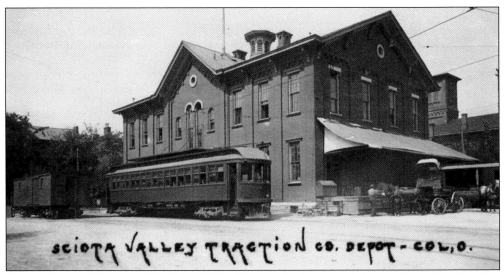

SCIOTO VALLEY STATION. The Scioto Valley Traction Station served the one interurban line that chose not to use the interurban station pictured above. The Scioto Valley maintained their station in the former Rich Street School on the northeast corner of Rich and Third Streets, directly across Third St. from the interurban station. The interurban line had established their station in this building in 1905. The Scioto Valley Traction line ran from Columbus to Obetz Junction, where it split with one line going to Groveport, Canal Winchester and Lancaster, and the other line going to Circleville and Chillicothe.

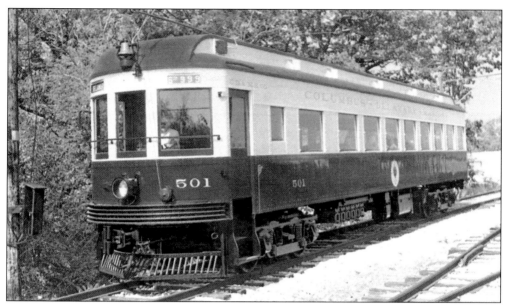

CD&M CAR. The Columbus, Delaware and Marion (CD&M) interurban electric railroad provided service between Columbus, Worthington, Delaware, and Marion from 1903 to 1933. A feature of the CD&M line was the 990-foot trestle over a ravine just north of Worthington. This postcard shows one of the two red and cream parlor cars operated by the CD&M. This car has been preserved at the Ohio Railway Museum.

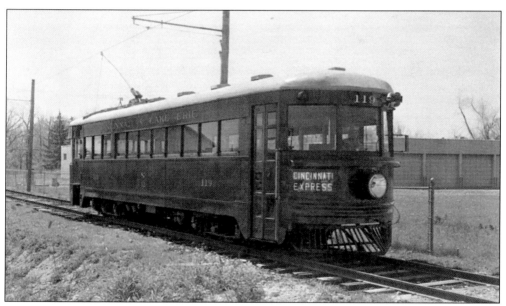

C&LE CAR. The Cincinnati and Lake Erie (C&LE) interurban electric railroad provided service from Columbus to Springfield, Dayton, Cincinnati, Lima, and Toledo from 1929 until 1938. These low-slung, lightweight cars could reach 80 miles per hour. To promote the C&LE, the owners staged a race between a C&LE car and an Indianapolis race car (on Route 40) and another race between a C&LE car and an airplane. Films of these events were used to demonstrate the speed of the interurban service. This maroon car is preserved at the Ohio Railway Museum.

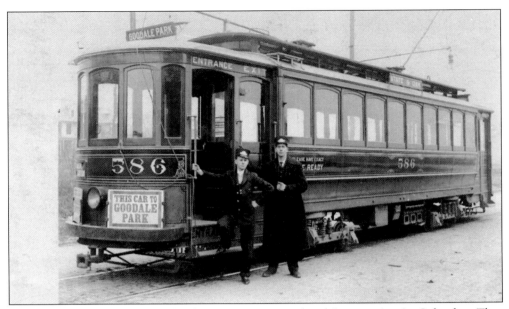

STREETCAR. In June of 1863 the first streetcars were placed in operation in Columbus. They were drawn by one or two horses or mules. About 1890 the Columbus streetcars began to be electrified. This postcard shows a 1910 vintage streetcar with its two-man operating crew—a motorman to operate the car and a conductor to collect the fares. However, as early as 1908 these streetcars began to be replaced with pay-as-you-enter (PAYE) cars with fare boxes, foreshadowing the days of the one-man cars.

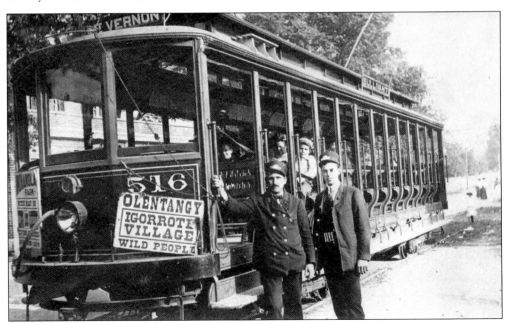

STREETCAR, SUMMER. During the summer, the streetcars were uncomfortably hot and stuffy. Thus, some cars were constructed with open sides for service during the summer. This summer car carries advertising for Columbus' two amusement parks—Olentangy Park and Indianola Park. Both parks were owned by the streetcar company.

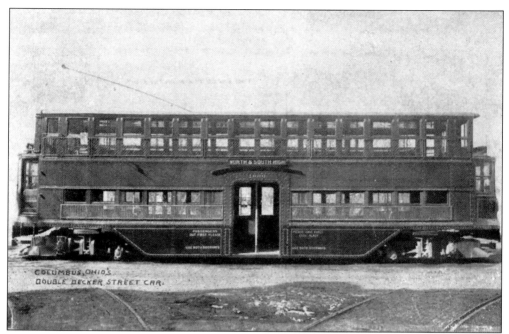

STREETCAR, DOUBLE DECK. In 1914 the Columbus Railway, Power & Light Company (CRP&L) experimented with a double deck streetcar. The obvious advantage was its higher capacity. Unfortunately, this large car had a large turning radius and, thus, could not be used on most routes. The use of double deck cars was abandoned after the brief trial.

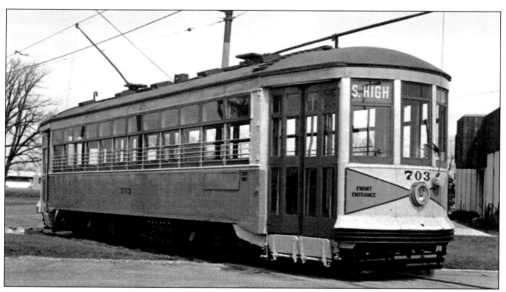

STREETCAR, MODERN. The CRP&L began to acquire more modern streetcars in 1926. Car No. 703 was built by the G.C. Kuhlman Car Co. and was among the last 23 streetcars that were purchased new by the CRP&L. Later cars were acquired used from other streetcar systems. Streetcars were abandoned in Columbus in 1948 in favor of electric trolley buses and gasoline and diesel-engine buses. Streetcar No. 703 was acquired by the Ohio Railway Museum and is still operated, although it does not have its original running gear.

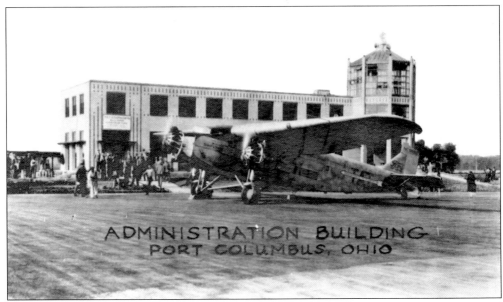

PORT COLUMBUS TERMINAL. Columbus's major airport, Port Columbus, was dedicated on July 8, 1929. It was constructed as part of an air-rail system to provide coast-to-coast transportation in 48 hours—two days by plane, two nights by train. It took four to five days to cross the continent by train. Columbus served as a transition point from rail to air (westbound) or air to rail (eastbound). This original Port Columbus passenger terminal building served from 1929 to 1958, when a new terminal was built in the present terminal location. The original terminal is located at the southeast corner of the airport and has been restored as an office building.

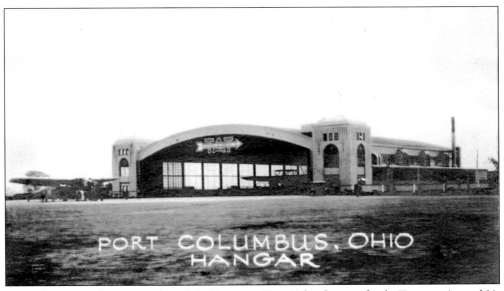

PORT COLUMBUS HANGAR. The original hangar at Port Columbus was for the Transcontinental Air Transport (TAT) airline. In 1930 TAT merged with Western Air Lines to form Transcontinental and Western Airlines. Still later it became Trans World Airlines, or TWA. Although the airline no longer exists, the hangar remains in use and is located just north of the original terminal building.

Four

HOTELS AND RESTAURANTS

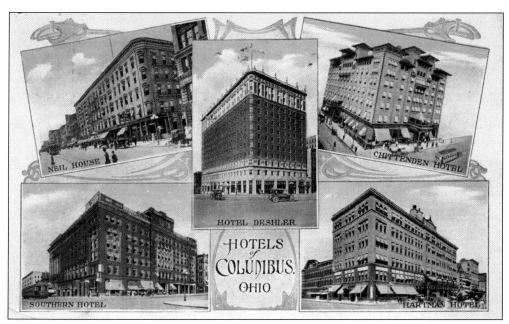

MULTIVIEW POSTCARD OF COLUMBUS HOTELS. This postcard shows the major downtown hotels as of about 1920. The hotels shown are the Neil House, the Hotel Deshler, the Chittenden Hotel, the Southern Hotel, and the Hartman Hotel.

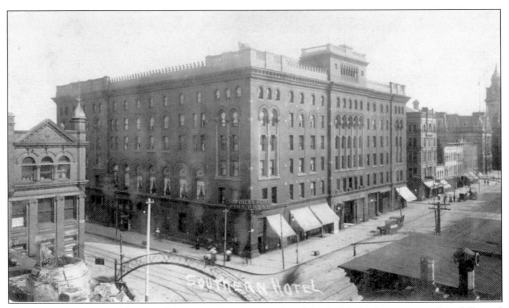

SOUTHERN HOTEL. The Southern Hotel was completed in 1896. As its construction followed several major fires in Columbus, a point was made to design the building as fireproof as possible, and this fact was used in promoting the hotel. It is the oldest operating hotel in Columbus. Restored in 1985, it now operates as the Westin Southern Hotel and is located on the southeast corner of High and Main Streets.

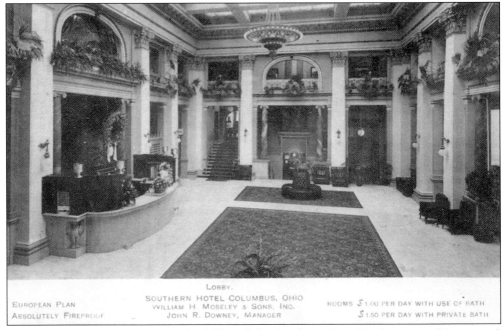

LOBBY.

SOUTHERN HOTEL COLUMBUS, OHIO
WILLIAM H. MOSELEY & SONS, INC.
JOHN R. DOWNEY, MANAGER

EUROPEAN PLAN
ABSOLUTELY FIREPROOF

ROOMS $1.00 PER DAY WITH USE OF BATH
$1.50 PER DAY WITH PRIVATE BATH

SOUTHERN HOTEL, INTERIOR. The lobby of the Southern Hotel is shown on this postcard. Information on the postcard states that the hotel operates on the European plan, that it is "absolutely fireproof," and that rates are $1 per day with use of bath and $1.50 per day with private bath. This postcard was postmarked in 1912.

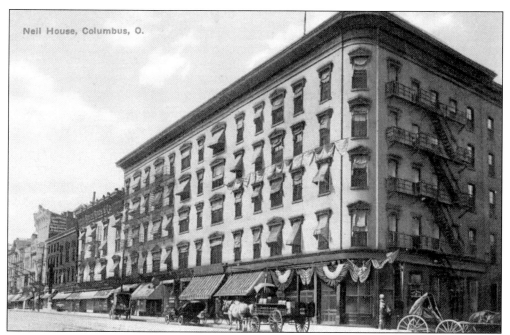

SECOND NEIL HOUSE. For over 140 years, the Neil House Hotel was a fixture on High Street opposite the State Capitol. This postcard shows the second Neil House building, erected in 1861–62, after the first Neil House was destroyed by fire. It offered 150 rooms. When William McKinley was governor of Ohio, he and his invalid wife roomed at the Neil House.

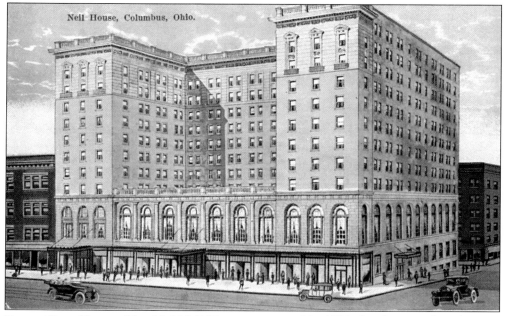

THIRD NEIL HOUSE. The third Neil House was erected in 1925 after the second Neil House was razed. Early postcards of this building state that it offered "655 rooms, every bedroom with private bath." Initial rates were $2.50 per night. The Neil House closed in 1980 and the building was razed in 1981 to make room for the Huntington Center.

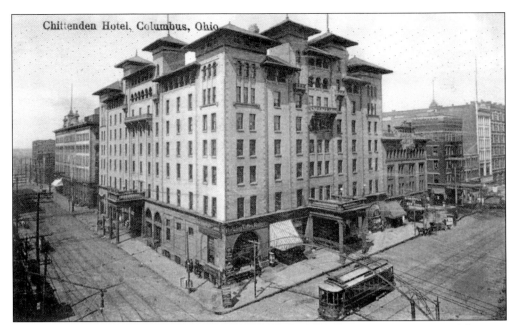

CHITTENDEN HOTEL. The first Chittenden Hotel opened in 1892 in a renovated business block on the northwest corner of High and Spring Streets. After it burned in 1893, the building shown in this postcard was constructed using 97 percent non-combustible material. The new hotel opened in 1895, was closed in 1972, and the building was razed in 1973. The eight-story Chittenden Hotel had 300 guest rooms. Although not shown on this postcard, for many years a sign picturing a jumping purple cow on the High Street side of the hotel advertised the Purple Cow coffee shop.

HARTMAN HOTEL. The Hartman building is located on the northwest corner of Main and Fourth Streets. It opened as a manufacturing building in 1898 and was reopened as the Hartman Sanitarium in January of 1901. It was later converted to a hotel, and still later the building was occupied by a bank and the Ohio Bureau of Motor Vehicles. It was in the process of being renovated in 2001.

NORWICH HOTEL. The Norwich Hotel building was built as an office building in 1890. It was converted into a hotel in 1893 and was converted back to office use in 1986. It is located on the northeast corner of State and Fourth Streets.

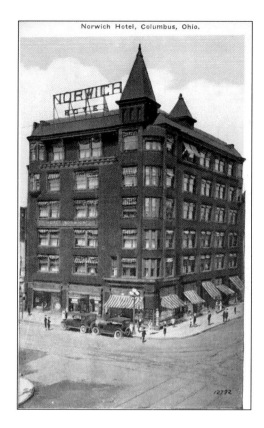

Norwich Hotel, Columbus, Ohio.

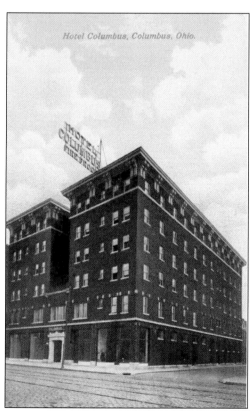

Hotel Columbus, Columbus, Ohio.

HOTEL COLUMBUS. The Hotel Columbus opened in 1912 at 235–243 E. Long Street. It closed in 1977 and the building was razed in 1979.

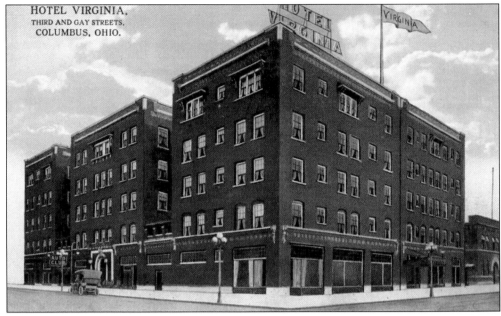

VIRGINIA HOTEL. The Virginia Hotel opened as the Virginia Apartments in 1908, on the southeast corner of Gay and Third Streets, by Dr. Samuel B. Hartman of Peruna fame. It was named for a daughter of Frederick W. Schumacher, son-in-law of Dr. Hartman. Reopened as a hotel in 1911, it had several stately rooms—the ballroom, the Cavalier Room, and the lower-level room later occupied by the City Club. In its later years, it was popular with actors, musicians, and baseball players. The Virginia Hotel was closed and razed in 1961.

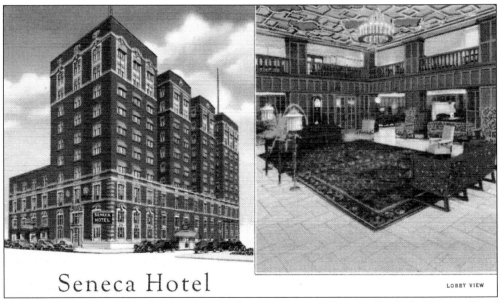

SENECA HOTEL. Designed by noted Columbus architect Frank L. Packard, the Seneca Hotel was built in 1917 as an apartment hotel. A four-story addition was constructed on its east side in 1924. Closed as a hotel, it was later used as offices by the Ohio Environmental Protection Agency. Located at 361 E. Broad Street, it has been closed since 1989 and awaits restoration or razing.

DESHLER HOTEL. The Deshler Hotel was the showplace of Columbus when it opened on August 23, 1916, on the northwest corner of Broad and High Streets. It was described as containing "four hundred rooms of which three hundred and fifty will have private baths and the balance will have running water." It closed in 1968 and the building was razed in September 1969. This postcard shows the Deshler Hotel before the construction of the AIU Citadel beside it.

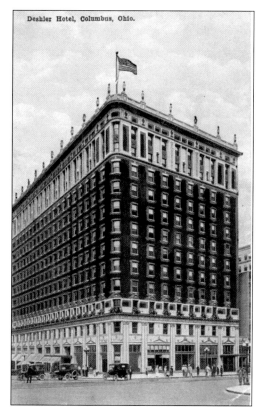

Deshler Hotel, Columbus, Ohio.

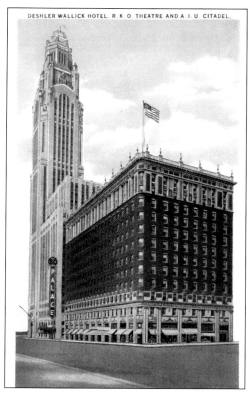

DESHLER WALLICK HOTEL. R. K. O. THEATRE AND A. I. U. CITADEL.

DESHLER HOTEL WITH AIU CITADEL. When the AIU Citadel opened across the alley from the Deshler Hotel in 1927, some of its space was leased to the hotel in order to increase the hotel's capacity by 600 rooms. A bridge was constructed from the Deshler Hotel to the AIU Citadel, enabling patrons to pass between the two buildings.

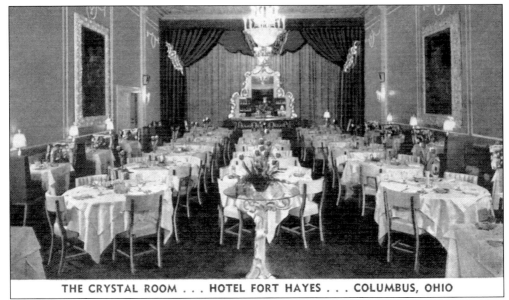

THE CRYSTAL ROOM . . . HOTEL FORT HAYES . . . COLUMBUS, OHIO

HOTEL FORT HAYES, INTERIOR. The Hotel Ft. Hayes was located at 33 W. Spring Street. It opened in 1924. Sarah Bernhart's jewelry was on display for the opening ceremonies. For part of its existence, it was operated as an Albert Pick Hotel. The back of the postcard advertises that the Hotel Ft. Hayes "contains 350 all outside rooms with bath and is located in the heart of the business and theatrical district." It closed and was razed in 1977.

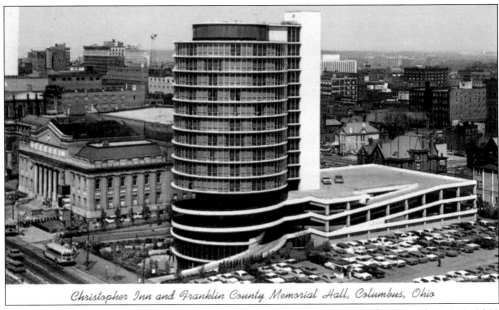

Christopher Inn and Franklin County Memorial Hall, Columbus, Ohio

CHRISTOPHER INN. Although the Christopher Inn does not exactly fit in to the 1898–1950 period covered by this book, the uniqueness of its design and the fact that it is an often-spoken-of hotel justifies its inclusion. Its unique feature was the round design, which determined both its outside profile and its interior room shapes. The Christopher Inn opened on July 29, 1963, and was razed in 1988. It was located as 300 E. Broad Street.

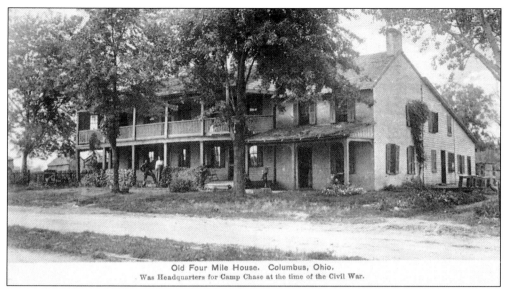

Old Four Mile House. Columbus, Ohio.
Was Headquarters for Camp Chase at the time of the Civil War.

FOUR MILE HOUSE. The Four Mile House was a popular inn on the National Road; especially during the Civil War, because of nearby Camp Chase. It offered a large warehouse nearby, for use by drivers of heavily loaded wagons, and a large yard by the warehouse provided a place for animals and for drovers that did not want to pay the price for a room. It was probably built soon after the National Road came through in 1836 and it was demolished in 1913. It was located four miles west of downtown Columbus at 2904 W. Broad Street, about two blocks west of Hague Avenue.

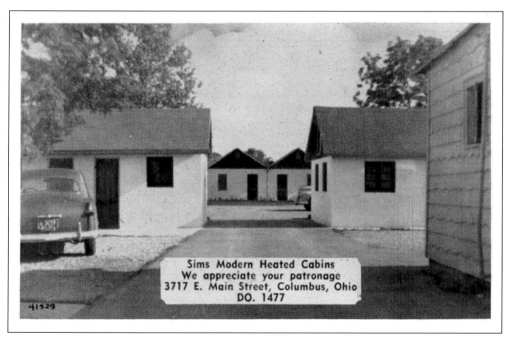

Sims Modern Heated Cabins
We appreciate your patronage
3717 E. Main Street, Columbus, Ohio
DO. 1477

CABINS FOR TRAVELERS. The Sims Cabins is an example of the cabin-style accommodations that were popular during the 1950s. Before the days of the modern motel, automobile travelers could choose this type of accommodation and have an entire cabin to themselves. It is interesting to note that they found it necessary to advertise that the cabins were heated.

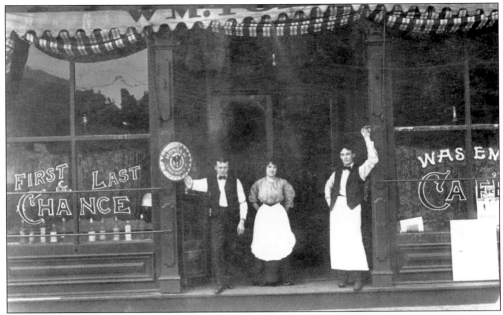

First and Last Chance Saloon. The First and Last Chance Saloon was Papa Presutti's first business venture after coming to America. It opened in 1908 in an area known as Flytown. When Prohibition destroyed the saloon business, he became a grocer and a bootlegger. After Prohibition ended, Papa and Mama Presutti opened a restaurant that became one of Columbus's favorites. A sign near the doorway advertises Hoster Beer, a local Columbus product.

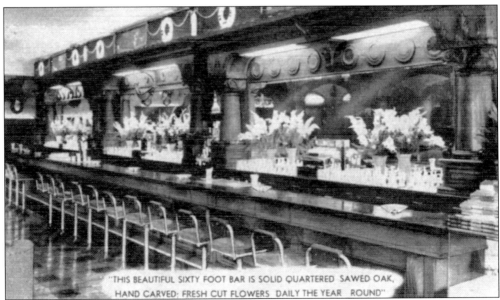

"THIS BEAUTIFUL SIXTY FOOT BAR IS SOLID QUARTERED SAWED OAK, HAND CARVED; FRESH CUT FLOWERS DAILY THE YEAR ROUND"

Jai Lai Restaurant. The Jai Lai restaurant opened at 585–593 N. High Street in 1933. When the Goodale leg of the Columbus interbelt (I-670) was constructed, the Jai Lai was displaced. It was relocated to 1421 Olentangy River Road, where it opened in 1955. This 60-foot bar was moved to the new location. The Jai Lai closed on August 1, 1996. On Oct. 12, 1997, the building was reopened as the Buckeye Hall of Fame Café.

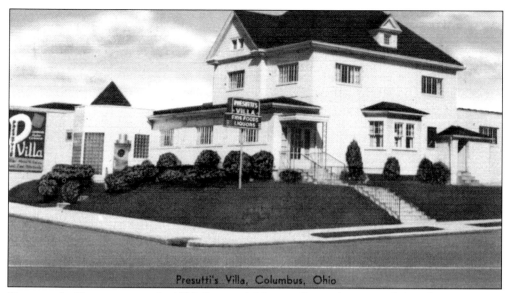

Presutti's Villa, Columbus, Ohio

PRESUTTI'S RESTAURANT. In 1933 Papa and Mamma Presutti converted their home at 1692 W. Fifth Avenue into a restaurant featuring Italian food. The restaurant was so successful that there were numerous additions to the building, beginning with the Crystalier Room in 1935. Later additions included the Champagne Room and the Empire Room. A 1960 menu offered "spaghetti, served with Mamma and Pop Presutti's original tomato sauce, Romano cheese, large fresh garden Italian tossed salad, garlic bread" for $1.95. Presutti's closed in 1981.

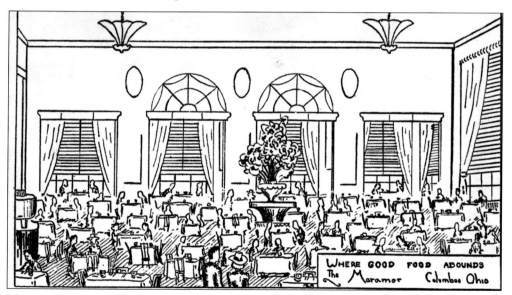

WHERE GOOD FOOD ABOUNDS
The Maramor Columbus Ohio

MARAMOUR RESTAURANT. The Maramour Restaurant was long considered one of finest restaurants in central Ohio. The second Maramor, built in 1926, was located in downtown Columbus at 137 E. Broad Street. A booklet from the Maramour states that "In the Maramour Celebrity Book you'll find, over the signatures of famous people, including many high in the theatrical world, such phrases as, 'My respects to the finest restaurant ever,' and 'Six hundred miles isn't too far to drive to have lunch at The Maramour every noon for a week.'" It closed in 1971 and was razed in 1972.

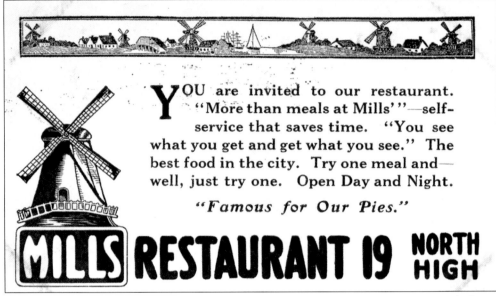

YOU are invited to our restaurant. "More than meals at Mills'"—self-service that saves time. "You see what you get and get what you see." The best food in the city. Try one meal and—well, just try one. Open Day and Night.

"Famous for Our Pies."

MILLS RESTAURANT 19 NORTH HIGH

MILLS RESTAURANT AD. This postcard advertises the Mills Restaurant at 19 N. High Street. Mills Restaurants were cafeterias, thus the claim that "You see what you get and get what you see." For many years the Mills Restaurants (there was another at 77 S. High Street) were popular eating places in Columbus, especially for downtown shoppers. The Mills at 19 N. High Street was adjacent to the Deshler Hotel.

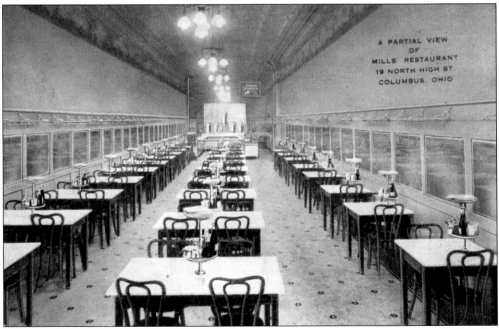

MILLS RESTAURANT. The Mills Restaurant at 19 N. High St. opened in 1913 and closed in 1967. Mills Restaurants offered what, for their day, must have been a sterile environment—no tablecloths, little in the way of decorations, etc. However, today, with our exposure to McDonalds, Wendy's, and similar restaurant chains, it does not seem that unusual.

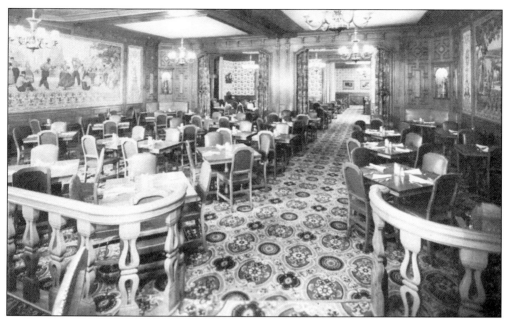

KUENNING'S RESTAURANT. Kuenning's Midtown Restaurant took over the operation of a restaurant at 19 N. High Street after the Mills Restaurant closed. Kuenning's offered a higher class dining experience and, despite the higher prices that must have accompanied the enhanced décor, earned its own reputation as a popular dining spot in Columbus. It closed in 1972.

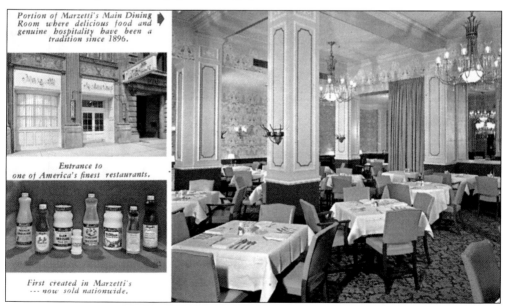

Portion of Marzetti's Main Dining Room where delicious food and genuine hospitality have been a tradition since 1896.

Entrance to one of America's finest restaurants.

First created in Marzetti's --- now sold nationwide.

MARZETTI'S RESTAURANT. The first Marzetti's Restaurant had opened by 1904 at 1548 N. High Street. In 1919 a second Marzetti's Restaurant was opened at 59 E. Gay Street. The N. High Street restaurant continued to be operated for about six years and then was closed. In 1942 Marzetti's moved from Gay Street to the first floor of the Hayden Building at 16 E. Broad St. Marzetti's Restaurant closed in 1971. By 1929 a separate company, Marzetti & Co., was formed to produce salad dressings.

The Beggs Restaurant, 7th Floor

The Saturday Evening Supper at The Beggs Restaurant

Noodle Soup

Sweet Pickles

Fried Chicken, Maryland Style

New Potatoes, Parsley Butter *Corn Fritters*

Hot Rolls

Fresh Strawberries with Ice Cream

Coffee *Tea* *Milk*

40 Cents the Supper

Come and bring the family---it's a regular home supper

BEGGS STORE, MENU. The Beggs Department store opened at 34–38 N. High Street about 1892. By 1907 it had been relocated to the southeast corner of Chestnut and High Streets. A feature of the Beggs store at the latter location was the Saturday night dinner in the seventh-floor restaurant. This postcard shows that a fried chicken dinner, Maryland Style, with all the trimmings including beverage and dessert, could be enjoyed for only 40¢.

Five

FAMILY LIFE

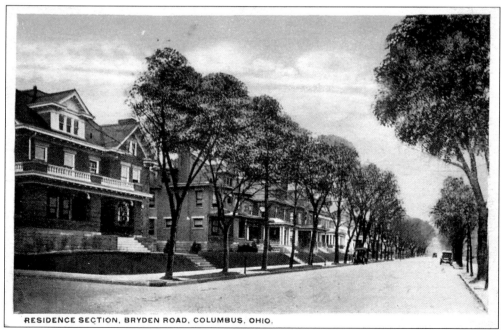

RESIDENCE SECTION, BRYDEN ROAD, COLUMBUS, OHIO.

HOUSES ON BRYDEN ROAD. This postcard shows houses on Bryden Road, a street running east from Parsons Avenue. At the turn of the twentieth century, Bryden was one of the upper-class residential neighborhoods in Columbus with prominent Columbus citizens living there. Over the years the neighborhood deteriorated, but more recently there has been interest in its restoration.

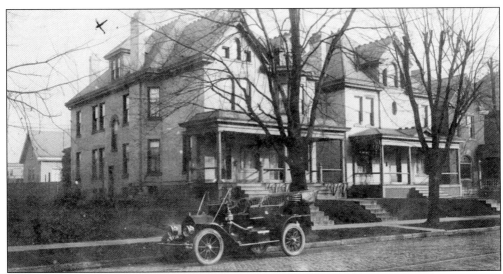

HOUSES ON NEIL AVENUE. Real photo postcards could be produced by anyone with the correct size camera. The photographs would be printed on heavyweight paper with the back marked "Postcard" and a place for the stamp. The availability of any of these cards depends on how many the photographer had printed; many are one-of-a-kind. Most show unidentifiable scenes, but occasionally one is able to identify the location. This real photo postcard shows houses at 1530 and 1534–36 Neil Avenue in Columbus.

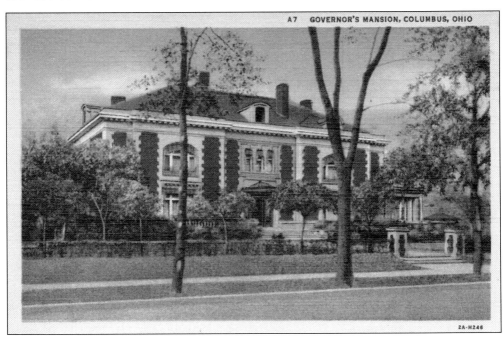

GOVERNOR'S MANSION. Ohio's one-time governor's mansion was built in 1904 as a residence for Charles H. Lindenberg, a manufacturer of pianos. It was designed by Frank Packard, one of Columbus' most prolific architects. It served as the governor's residence from 1920 to 1956 and as a depository for state archives from 1957 until 1970. The building, located at 1234 E. Broad Street, is now the home of the Columbus Foundation.

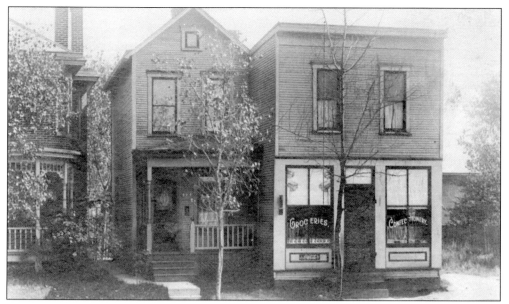

NEIGHBORHOOD GROCERY. As late as the 1960s, there were still many small neighborhood grocery stores in Columbus. These stores generally were within walking distance of the customers. This postcard shows a neighborhood grocery store located at 526 S. Ohio Avenue. The grocery store was on the first floor, and a residence (possibly of the store owner) was on the second floor.

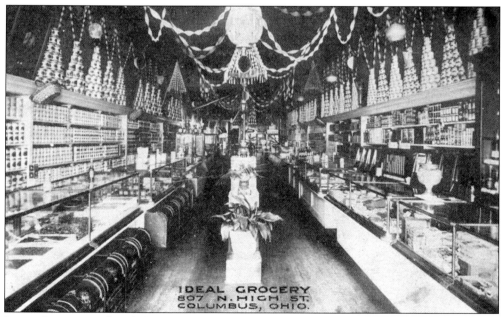

IDEAL GROCERY. The Ideal Grocery at 807 N. High St., as shown on this postcard, was typical of the larger neighborhood grocery stores. As contrasted to today's supermarkets with the customers selecting the merchandise and then checking out, the neighborhood grocery stores had most of the merchandise behind the counter and the customers had to ask for what they wanted. As supermarkets proliferated and automobile use increased, the neighborhood grocery stores faded from the scene.

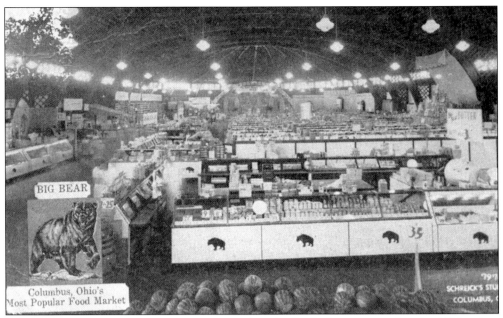

BIG BEAR SUPERMARKET. Big Bear opened Columbus's first supermarket in 1934, when they converted a former dance hall, the Crystal Slipper at 386 West Lane Avenue, into a supermarket. The building remained a supermarket until 1985. The building was then razed so that an apartment building could be built on the site. It has been claimed that this was the first supermarket in the United States.

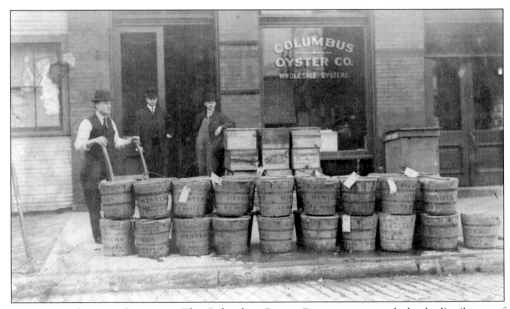

COLUMBUS OYSTER COMPANY. The Columbus Oyster Company was a wholesale distributor of fresh oysters. The oysters must have been brought from the east coast by express train. The back of the postcard, postmarked in 1909, offers standard oysters for $1.20 and Connecticut oysters for $1.45 per gallon. The kegs in front of the store identify the contents as Maryland Beauty Brand oysters from Baltimore.

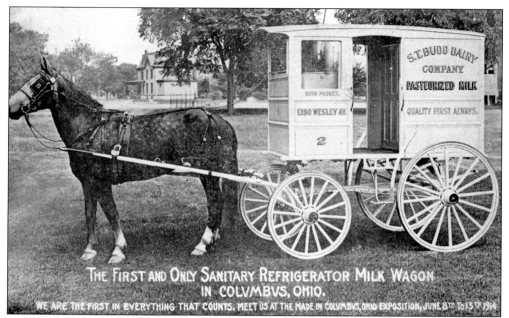

MILK DELIVERY. Home delivery of milk was a service provided by dairy companies throughout the first half of the 20th Century. Typically, delivery was three times a week, either Monday-Wednesday-Friday or Tuesday-Thursday-Saturday. The homeowner left empty bottles and the order on the front porch, and the milkman left the filled bottles and other dairy products such as cottage cheese. Horses were used to deliver milk in Columbus until after World War II.

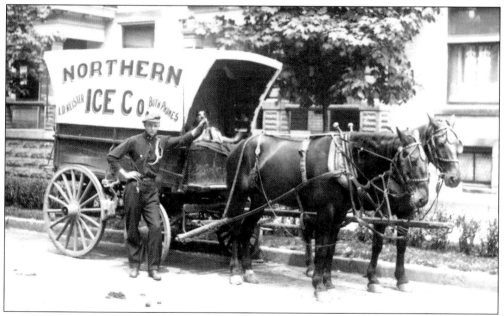

NORTHERN ICE WAGON. Before the refrigerator became an essential appliance in every household, families preserved milk and foods in ice boxes—well-insulated boxes that were cooled by ice. The ice man would deliver ice several times a week. The Northern Ice Company was located at 1138 North High Street in 1913.

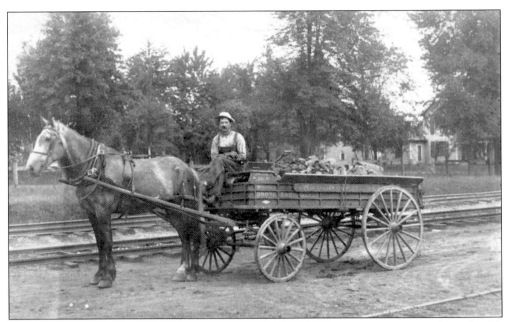

COAL WAGON. In the days before natural gas heating, virtually all houses were heated with coal-fired furnaces. Thus, it was necessary to have coal delivered to the house. Although the lettering on the wagon is for the Throop-Martin Company and advertises wholesale doors, sash, and windows, the wagon appears to be transporting a load of coal.

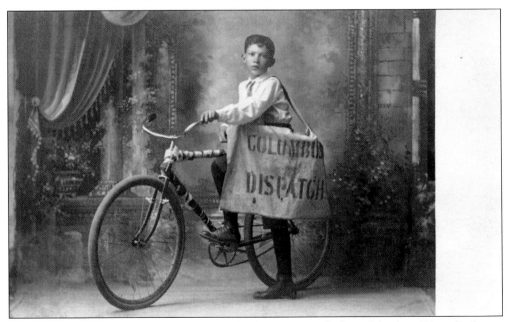

DISPATCH NEWSBOY. The *Daily Dispatch* (later renamed the *Columbus Dispatch*) began publication on July 1, 1871. This real photo postcard shows a newsboy, his newspaper bag, and his bicycle posed in front of a backdrop at a photographic studio. If one looks closely it can be seen that the boy is wearing a tie, which is not characteristic of later-day newsboys. The postcard most likely dates from about 1910.

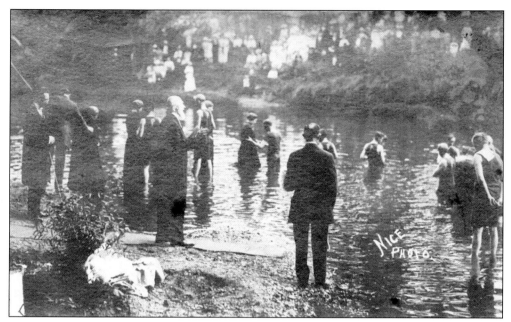

BAPTISM IN ALUM CREEK. The baptism shown on this postcard was held in conjunction with a meeting of the International Bible Students Association. The message on this postcard reads: "We are enjoying ourselves fine. This is a picture taken at Alum Creek Tuesday—70 were baptized—tomorrow will be baptizing day again. 2000 are attending convention here. We came up last Sunday. Will be home on Monday." It was postmarked July 3, 1914, in Columbus.

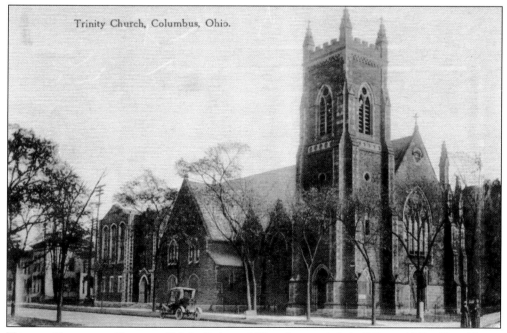

TRINITY EPISCOPAL CHURCH. Trinity Episcopal Church occupied a building at 10 East Broad Street from 1833 to 1868, when it was razed. The new building, shown here, was completed in 1869 at 125 E. Broad Street.

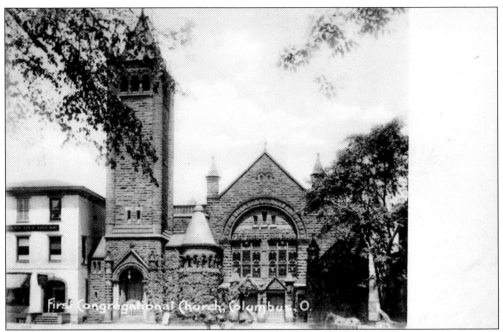

FIRST CONGREGATIONAL CHURCH, OLD. This First Congregational Church was built at 74 E. Broad Street, across from the State Capitol, as a brick structure in 1857. It was extensively remodeled and enlarged in 1886, including changing the brick front to stone. Dr. Washington Gladden served as pastor of this congregation from 1882 until his death in 1918. Gladden was known as the developer of the social gospel. The congregation abandoned this site in 1931.

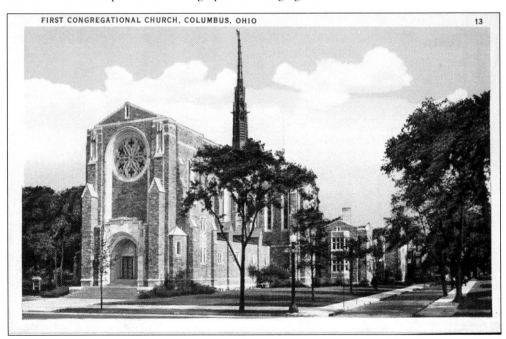

FIRST CONGREGATIONAL CHURCH, NEW. The new First Congregation Church was completed at 444 E. Broad Street in 1931. An addition was constructed in 1963.

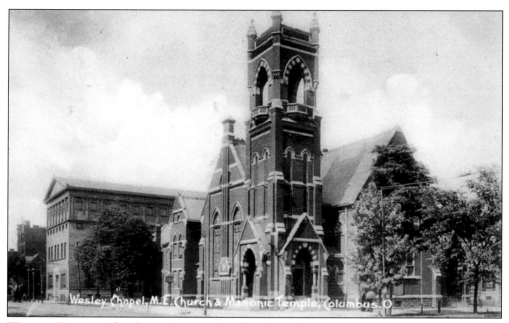

WESLEY CHAPEL. After the previous Wesley Chapel was destroyed by fire, the congregation built a new church on the northeast corner of Fourth and Broad Streets. It was dedicated on July 26, 1885. In 1912 it was renamed Central Methodist Episcopal Church. In 1935 the building was razed.

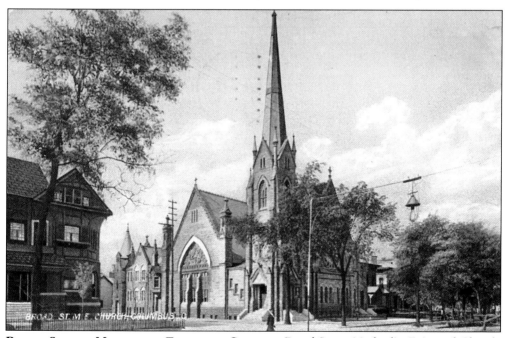

BROAD STREET METHODIST EPISCOPAL CHURCH. Broad Street Methodist Episcopal Church, located on the southwest corner of Broad Street and Washington Avenue, was completed in 1885. It replaced a frame building that had been erected on the same site in 1875. Many people refer to the present church as the "green church" because of the green shade of the serpentine stone from which it was constructed.

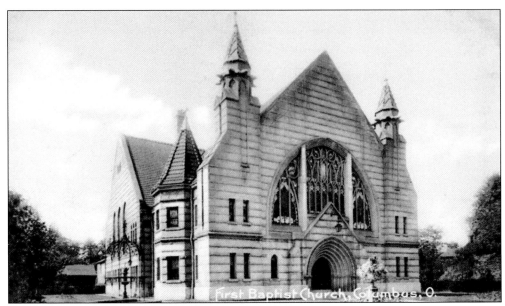

FIRST BAPTIST CHURCH. The First Baptist Church relocated to 583 E. Broad Street in 1897. Services were held in a yellow wooden "tabernacle" while the church building was being erected. The first services in the church were held on March 24, 1899. By 1925 the church had become overcrowded. During rebuilding to increase capacity, services were first held at the Hartman Theater and then jointly with the Broad Street Methodist Episcopal Church. The rebuilt facility was dedicated in January 1927.

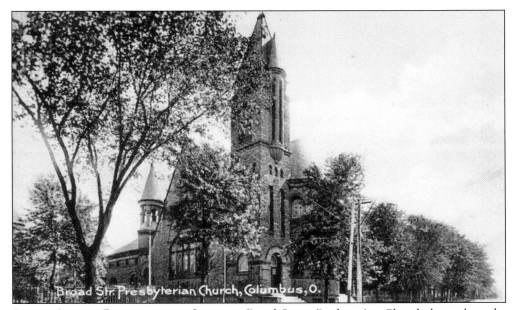

BROAD STREET PRESBYTERIAN CHURCH. Broad Street Presbyterian Church, located on the northeast corner of Broad and Garfield Streets, was completed in 1894. Alterations in 1907 and 1908 extended the church's east wall and doubled the size of the auditorium. The church features two outstanding Tiffany Studios stained glass windows. One depicts "Christ Blessing Little Children" and the other "The Resurrection."

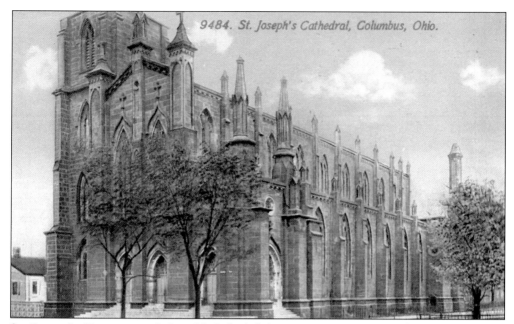

9484. St. Joseph's Cathedral, Columbus, Ohio.

ST. JOSEPH'S CATHEDRAL. St. Joseph's Cathedral sits on a spot at 212 E. Broad Street intended for a parish church. Construction was begun in 1866 with the excavation and laying of the foundation. However, when Columbus was made a diocese in 1868, Bishop Rosecrans decided that the site should be occupied by a cathedral. The plans were redrawn, the foundation was removed, and this structure was built. The building was dedicated on Oct. 20, 1878. The interior has been remodeled three times, but the exterior appears to remain much as originally constructed.

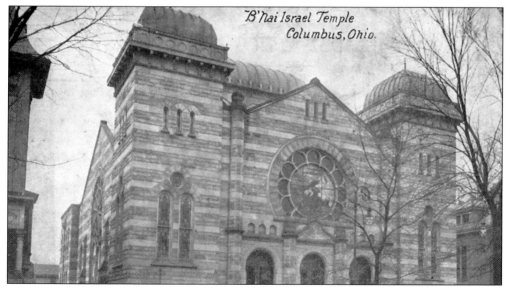

B'nai Israel Temple
Columbus, Ohio.

B'NAI ISRAEL TEMPLE. The B'nai Israel Temple was completed in 1904 to serve as the synagogue for a Reform Jewish community. It replaced an earlier temple that was located on the northeast corner of Friend (now Main) and Third Streets, which had served from 1870 to 1904. The new temple was located on Bryden Road between 18th and 19th Streets and served from 1904 until the congregation relocated to E. Broad Street in 1959.

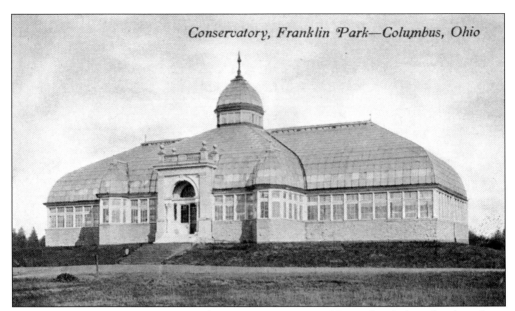

Conservatory, Franklin Park—Columbus, Ohio

FRANKLIN PARK CONSERVATORY. The conservatory at Franklin Park is believed to have been modeled after the much larger Horticulture Building at the 1893 World's Columbian Exposition. The conservatory was completed in 1895 and has been expanded several times. Franklin Park was the site of Ohio State Fairs from 1874 to 1885 and later became a city park. It hosted Ameriflora in 1992. Franklin Park is located at 1800 E. Broad Street.

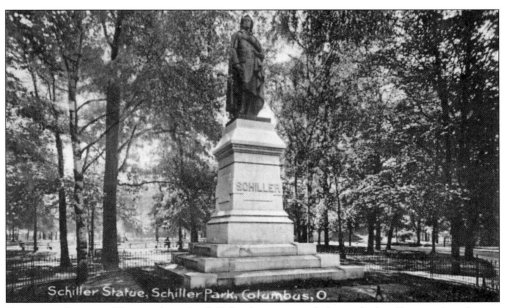

SCHILLER STATUE. The south end of Columbus was settled mostly by German immigrants who came to America beginning in the 1830s and continuing through the 1880s. Much of the architecture of the area has been preserved in what became known as German Village in 1960. The Frederick von Schiller statue was unveiled in City Park as a gift to the citizens of Columbus by the German residents on July 4, 1891. The name of the park was later changed to Schiller Park in 1905, to Washington Park in 1918, and back to Schiller Park in 1930.

Six

EDUCATION

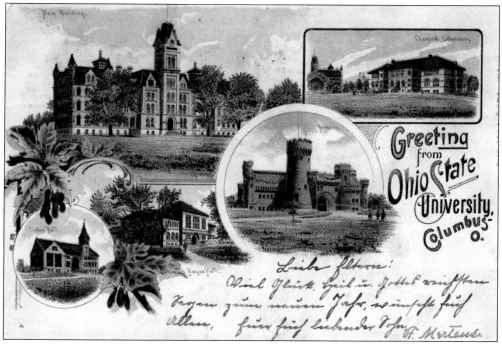

MULTIVIEW POSTCARD OF OSU BUILDINGS. A private mailing card from 1898 of Ohio State University shows an artist's renderings of some of the university's older buildings—University Hall, the Chemical Laboratory, Orton Hall, Hayes Hall, and the Armory.

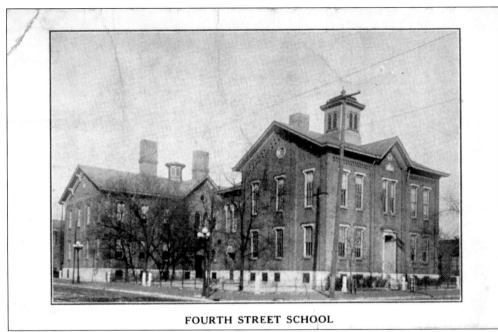

FOURTH STREET SCHOOL

FOURTH STREET SCHOOL. This 1935 postcard shows the two buildings of the Fourth Street School. The older building was constructed in 1852 and was originally known as the German-English School. A second building was erected in 1871 and was originally known as the Central Fulton School. The site was abandoned as a school in 1953, but continued to be used for other purposes until razed to clear land for the I-70 freeway.

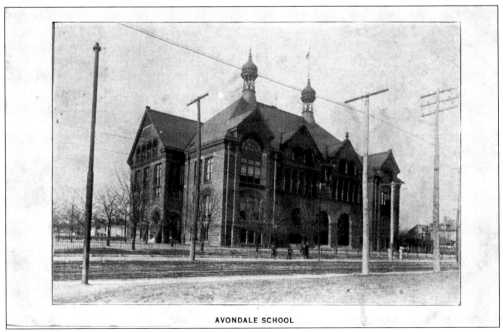

AVONDALE SCHOOL

AVONDALE SCHOOL. Avondale Elementary School is one of the oldest schools still in use in Columbus. It was built 1891 at 156 S. Avondale Avenue.

INDIANOLA JUNIOR HIGH SCHOOL. Indianola Junior High School, the nation's first junior high school, was opened in 1909 in response to concern by Columbus school administrators regarding the high number of dropouts at the end of the eighth grade. The concept was successful and was subsequently adopted for the entire city and by many other communities. This postcard shows the building at 16th and Indianola Avenue that Indianola Junior High School occupied from 1909 to 1929; it became Indianola Elementary School after the junior high school moved to a new building.

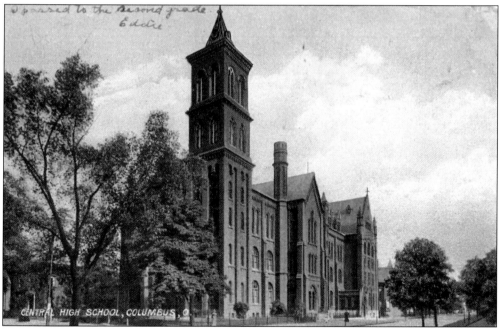

FIRST CENTRAL HIGH SCHOOL. Columbus' original high school building was erected in 1861 at Broad and Sixth Streets on a foundation that originally had been laid for Trinity Episcopal Church. Additions were erected in 1877 and 1890. This remained Columbus's only high school until North High School was opened in 1893. After South, East, and West High Schools were constructed at the turn of the century, this building was renamed Commercial High School. It served until 1924, when the new Central High school opened.

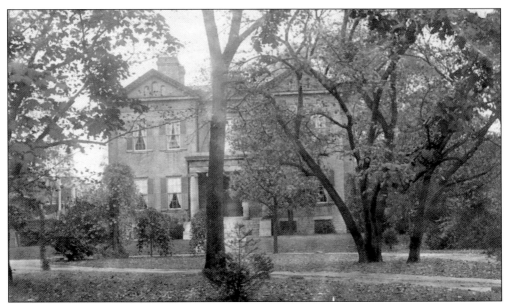

COLUMBUS SCHOOL FOR GIRLS. The Columbus School for Girls, which opened in 1898, occupied this building on the northeast corner of Town Street and Parsons Avenue from 1901 until it relocated to Bexley in 1953. Before being occupied by the school, this facility was known as Elmhurst, the Parsons family mansion. It was razed shortly after the school moved.

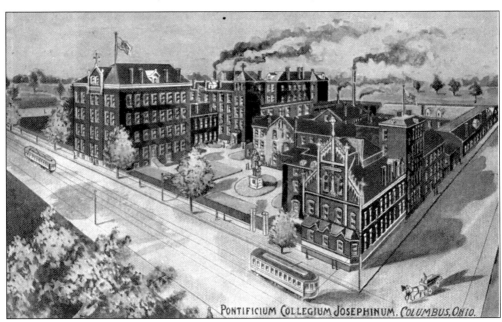

PONTIFICIUM COLLEGIUM JOSEPHINUM. *COLUMBUS, OHIO.*

JOSEPHINUM, OLD. Rev. Joseph Jessings moved his St. Joseph's Orphan Asylum from Pomeroy, Ohio, to Columbus in 1877. The next year the new St. Joseph's Orphanage Asylum was dedicated in Columbus. In 1888 Msgr. Jessing began a seminary, College Josephinum, at the orphan asylum. Pope Leo XIII accepted the College Josephinum as the Pontifical College Josephinum, linking it directly to the Vatican in 1892; it is the only pontifical seminary outside of Italy. The Josephinum moved to a new facility in Worthington, Ohio, in 1931, and this facility was subsequently razed.

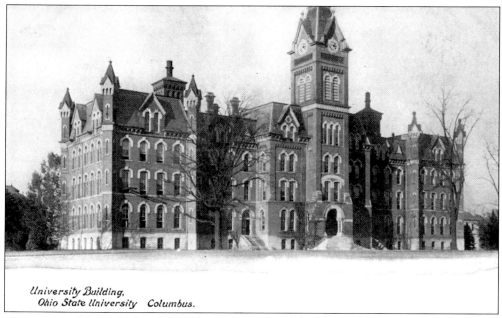

University Building,
Ohio State University Columbus.

UNIVERSITY HALL. University Hall was the original building of the Ohio Agricultural & Mechanical College (Ohio State University after 1878) when it opened in 1873. It served as both classrooms and dormitory until a dormitory building was completed. The building was razed in 1971 and replaced with a building of similar design that was dedicated in 1976.

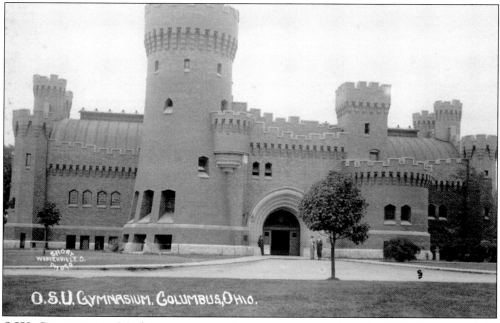

O.S.U. GYMNASIUM, COLUMBUS, OHIO.

OSU GYMNASIUM. OSU's gymnasium and armory was completed in 1898. It was used for ROTC and athletic and social events, and it was the home for the OSU basketball team from 1898 to 1919. A fire severely damaged the building on May 16, 1958, and it was razed in 1959. Today the gymnasium site is occupied by the Wexner Center for the Arts.

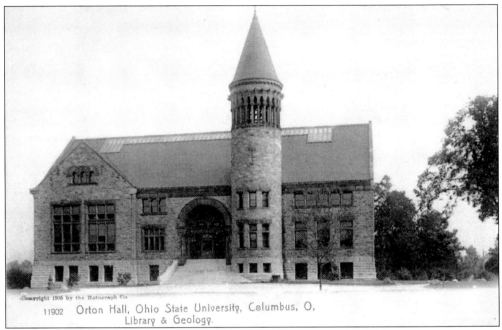

11902 Orton Hall, Ohio State University, Columbus, O,
Library & Geology.

ORTON HALL. Orton Hall was designed by Yost & Packard to reflect Ohio's geological history, with the oldest rocks at the base and progressively younger rocks at higher levels. Completed in 1893, it housed the geology department and museum, as well as the university library. The memorial chimes and the carillon were installed in Orton Hall in 1915. Orton Hall, named for OSU's first president, Dr. Edward Orton, is located at 155 Oval Drive South.

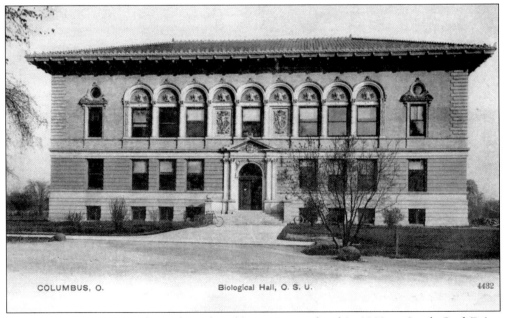

COLUMBUS, O. Biological Hall, O. S. U. 4432

BIOLOGICAL BUILDING. The Biological Building was completed in 1898 on South Oval Drive. In 1925 the Commerce Building (later Hagerty Hall) was erected on the site formerly occupied by the Biological Building.

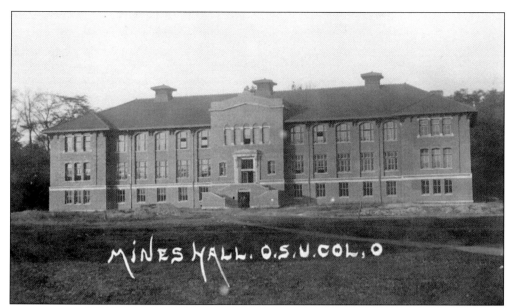

MINES BUILDING, LORD HALL. Originally known as the Mines Building, this building was constructed in 1905 for the Departments of Ceramics, Metallurgy, and Mining. It was dedicated as Lord Hall in 1912 in honor of Prof. Nathaniel W. Lord, a long time professor of metallurgy and mineralogy and the first dean of the College of Engineering. It is located at 124 W. 17th Avenue.

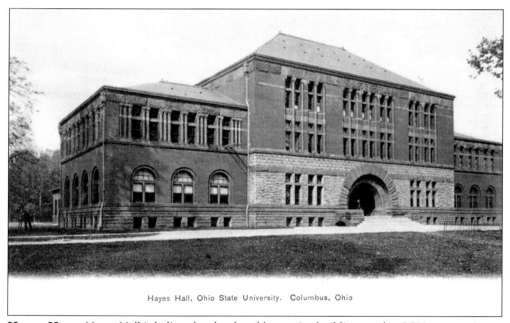

Hayes Hall, Ohio State University. Columbus, Ohio

HAYES HALL. Hayes Hall is believed to be the oldest major building on the OSU campus. It was opened in 1893 for use by the Departments of Manual Training, Drawing, and Home Economics. After these departments moved to newer buildings in 1915, Hayes Hall was shared by the School of Fine Arts and the student health service. Named for Rutherford B. Hayes, an Ohio governor and the 19th president of the United States, it is located at 108 Oval Drive North.

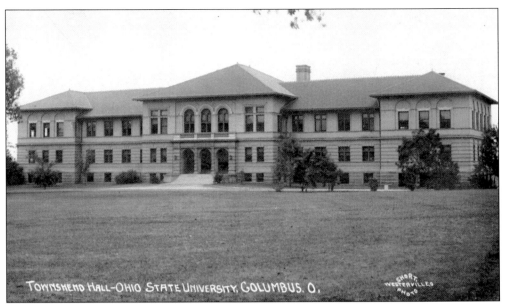

TOWNSHEND HALL. Townshend Hall was opened in 1898 at 1885 Neil Avenue. It was the first campus building erected for the College of Agriculture and was named for Dr. Norton S. Townshend, OSU's first professor of agriculture. The building contained a livestock room, where livestock could be exhibited and judged, and a dairy department, which included a pasteurizing room, a buttermaking room, and two cheese curing rooms.

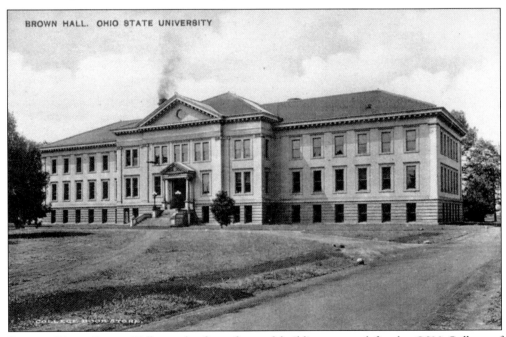

BROWN HALL. Brown Hall was the first of several buildings erected for the OSU College of Engineering. While under construction in 1903, the university trustees decided to name it after Prof. Christopher N. Brown, a Dean of the College of Engineering and for 20 years a professor of civil engineering. Brown Hall is located at 190 West 17th Avenue.

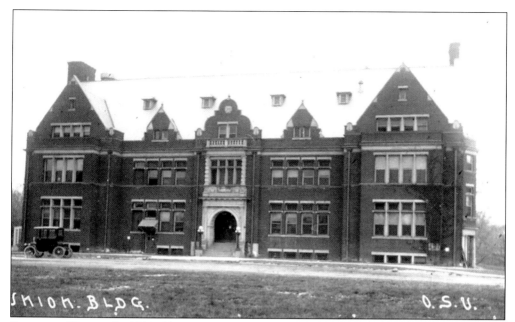

STUDENT UNION. In 1911 Ohio State University constructed this building as the first student union built at a public university. It served as OSU's student union until the new Ohio Union was opened in 1951. After that it served as a student health facility. It is located at 154 W. 12th Avenue.

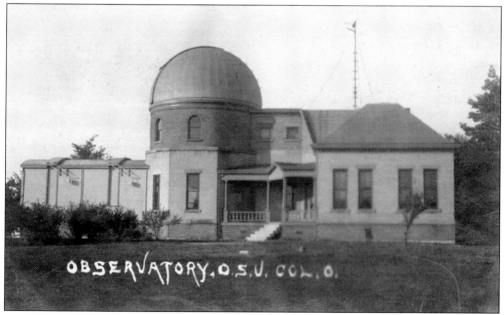

OSU OBSERVATORY. The McMillin Observatory was opened in 1896 at 236 West 12th Avenue on the Ohio State University campus. The observatory was made possible by the generous gift of $10,000 for equipment (including a twelve-inch telescope) by Emerson McMillin of New York City. The trustees acknowledged the gift by naming the facility the Emerson McMillin Astronomical Observatory. It was demolished in 1976.

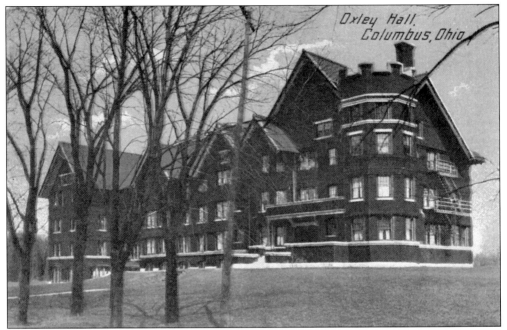

OXLEY HALL. Built in 1907–08, Oxley Hall was the first women's dorm at OSU. It was named for the mother of University President William Oxley Thompson. Located at 1712 Neil Avenue, today the building is known as the Enarson Hall Student Visitor Center.

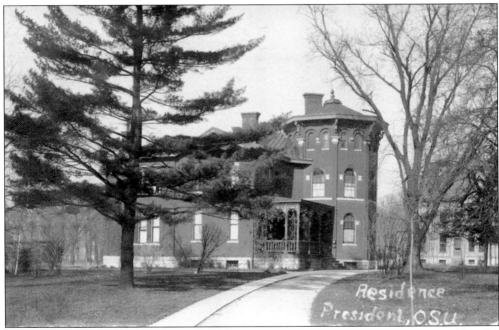

OSU PRESIDENT'S RESIDENCE. Originally built in 1856 as a home for Joseph Strickler, this house was located at 1873 N. High Street. During the years from 1873 to 1925, it served as the residence of the first five university presidents. Later it housed the music department. It was razed in 1949. Today the site is occupied by the Mershon Auditorium.

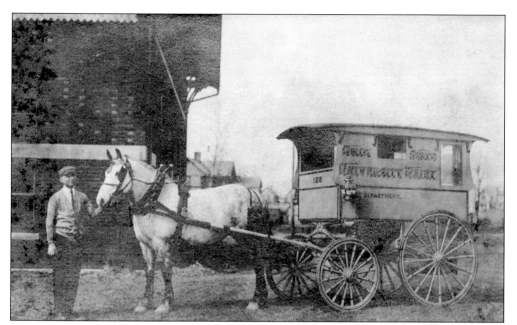

OSU DAIRY WAGON. A dairy school was established at OSU in 1895. In 1900 the OSU College of Agriculture began offering extension classes at various locations around the state. The Ohio State University Dairy wagon shown here may have been used in conjunction with these classes, or may have been used for distributing milk produced by the OSU dairy.

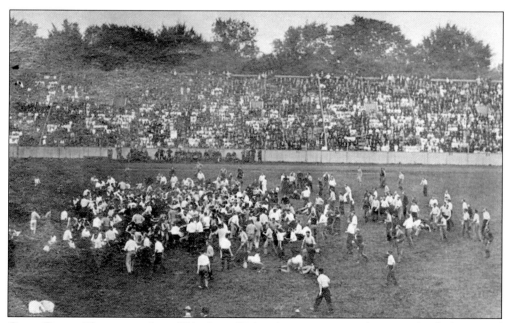

CANE RUSH. The cane rush at Ohio State University was a contest between the freshman and the sophomore classes. The two classes lined up on opposite ends of the football field and then attempted to hang a cane over the other team's goal post. From this and other postcards, these events appear to have been general melees.

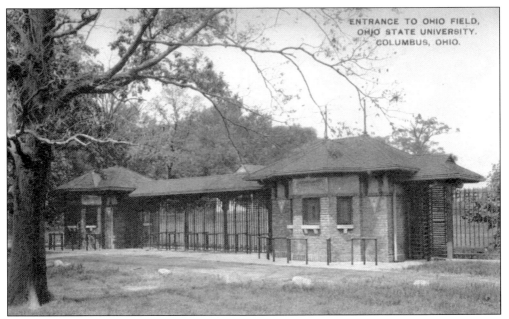

OHIO FIELD. Ohio Field was the site of OSU football games and other campus activities from 1903 to 1921. When Ohio State began to have championship football teams (1916 and 1917) drawing overflow crowds, the field became inadequate. It was located on the west side of N. High Street at Woodruff Avenue.

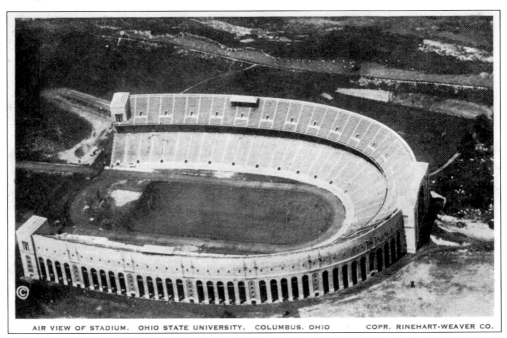

OHIO STADIUM. Ohio Stadium was built from 1921 to 1923 as a home for OSU football team. At the time many persons believed that the stadium, which initially sat 60,000, would never be filled. It was not until the 1950s that it was filled on a regular basis. After extensively remodeling in 1999–2001, it now has a capacity of 99,999.

1906 OSU FOOTBALL TEAM. The 1906 Ohio State University football team was one of the nation's finest. Not a touchdown was scored against them. They only yielded three field goals and a safety, and they outscored their opponents 153–14. Unfortunately, one of the field goals and the safety came in the game against Michigan, which they lost 6–0 (field goals counted 4 point then). Overall, they had an 8-win, 1-loss season.

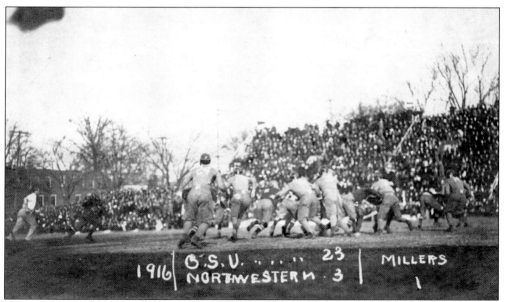

OSU GAME. Real photo postcards of early OSU football games are rare. This one shows the OSU versus Northwestern game at Ohio Field in 1916, which was won by OSU, 23–3. OSU's 1916 team was its first to win a Western Conference (now Big Ten) championship. Chic Harley played on the 1916 team as a freshman.

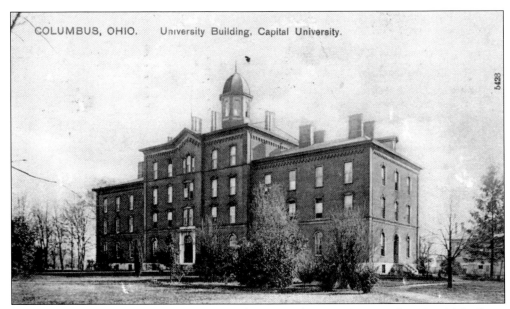

CAPITAL UNIVERSITY, LEHMANN HALL. When Capital University moved to East Main Street in Bexley in 1876, the entire university was housed in this one building. It contained 5 classrooms, 2 halls for the literary societies, and about 60 rooms for students, plus the living quarters for the house-father. It was later converted to a dormitory. It was named Lehmann Hall in honor of Wilhelm F. Lehmann, president of the university from 1857 until his death in 1880. Lehmann Hall was demolished in 1988.

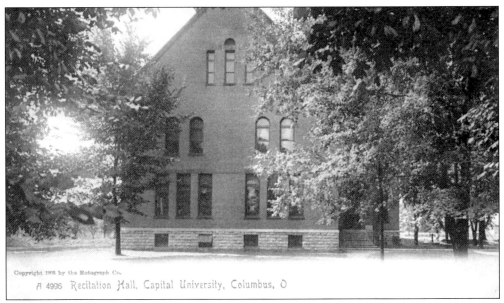

CAPITAL UNIVERSITY, RECITATION HALL. Recitation Hall was the second building constructed on the Capital University campus; it was completed in 1891. Much of the work in constructing the building was done by Capital students, either for partial credit on grades or for minimal wages. The building contained a large chapel, six recitation rooms, a library and a small laboratory. Recitation Hall was razed in 1969.

Seven

AMUSEMENTS AND ENTERTAINMENT

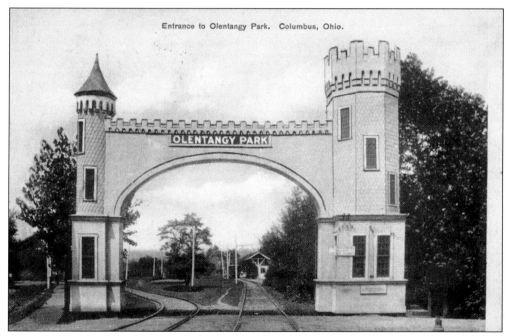

OLENTANGY PARK, ENTRANCE. Olentangy Park opened in 1897, primarily as a picnic and nature park. Within a few years, amusement rides and other attractions began to be installed, and by 1908 it was a 100-acre amusement park. It operated through the 1937 season. After that it was razed, and the Olentangy Village apartment complex was built on a portion of the land. Olentangy Park was located on the west side of N. High Street between North Street and Tulane Road.

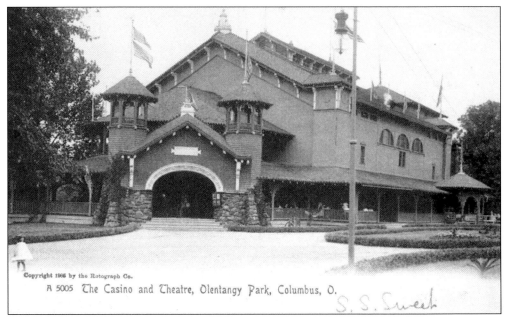

Copyright 1906 by the Rotograph Co.

A 5005 The Casino and Theatre, Olentangy Park, Columbus, O.

S. S. Sweet

OLENTANGY PARK, THEATRE. The theatre at Olentangy Park opened in 1899. It sat 2,400 persons and was the site of concerts, plays, and other attractions. It was a major summer entertainment spot for Columbus in the days before air conditioning of the downtown theaters. After sitting idle for 11 years, the theatre was razed in 1933.

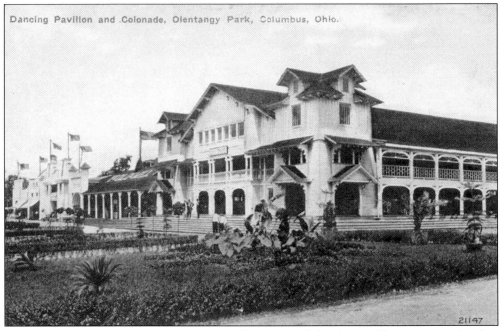

Dancing Pavilion and Colonade, Olentangy Park, Columbus, Ohio.

21147

OLENTANGY PARK, DANCING PAVILION. The new steel dancing pavilion was completed in 1908. Dancing was a popular activity during the late 1920s and the 1930s, partly due to the emergence of radio and records and partly because of the low cost of this form of entertainment during the Depression.

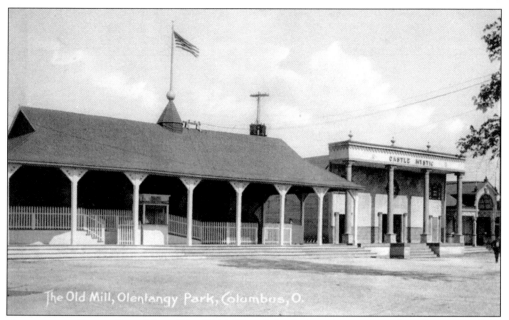

OLENTANGY PARK, OLD MILL. The Old Mill and Castle Mystic are remembered as some of the entertainment at Olentangy Park. The Old Mill ride was a tunnel-of-love boat ride.

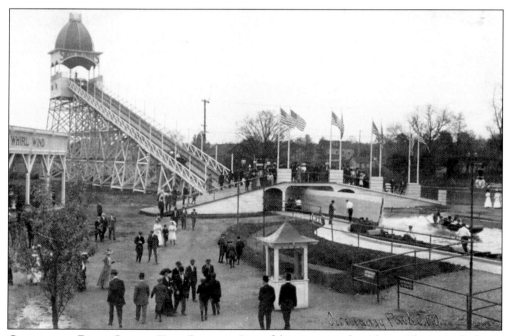

OLENTANGY PARK, SHOOT-THE-CHUTES. One of the most popular rides at Olentangy Park was the Shoot-the-Chutes. It was similar to the water rides at later amusement parks. A boat was pulled up a belt on one side of the incline, rotated at the top, and then allowed to slide down the other side of the incline and to splash in the pond at the bottom of the ride. Each boat was under the control of a young man who stood at the back of the boat, even during the ride down the incline.

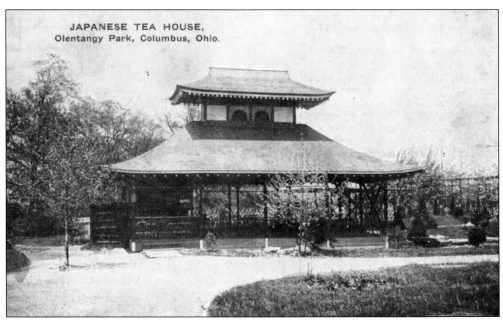

OLENTANGY PARK, FAIR JAPAN. The Fair Japan exhibit was purchased and brought to Olentangy Park after the close of the 1904 World's Fair in St. Louis. Among the attractions in the Fair Japan exhibit were the Japanese Tea House (shown here), a Japanese garden with a Banzai Bridge, Japanese houses, shops featuring Japanese souvenirs, and plants grown and trimmed to the shapes of swans and flamingos. In addition, Japanese performers were hired to display native dances and to demonstrate Japanese fighting techniques.

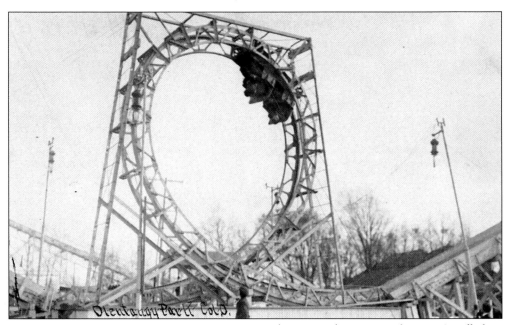

OLENTANGY PARK, LOOP-THE-LOOP RIDE. The Loop-the-Loop ride was installed at Olentangy Park in 1908. The car sat four persons. Reportedly, it was only operated for a few years due to accidents.

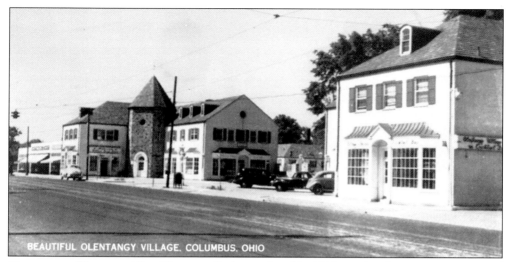

BEAUTIFUL OLENTANGY VILLAGE. COLUMBUS. OHIO

OLENTANGY VILLAGE. After Olentangy Park was closed in 1937, a strip of stores was constructed at the entrance to Olentangy Village, along the west side of High Street north and south of Kelso Road. This postcard shows these stores looking from the north. Although the businesses in these building change from time to time, the buildings have remained virtually unchanged over the years.

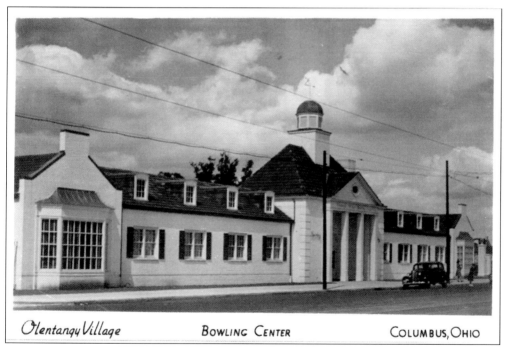

Olentangy Village BOWLING CENTER COLUMBUS, OHIO

OLENTANGY BOWLING ALLEY. The Olentangy Village Bowling Center was constructed along the west side of High Street just south of Olentangy Street. In addition to the 32 lanes for bowling, the facility offered billiards and indoor golf, as well as a shooting range in the basement. This bowling alley is reported to be the first one in Columbus with automatic pin-spotters. The patent for the pin-spotters was later sold to American Machine and Foundry (AMF). The building was destroyed by fire on Oct. 27, 1980.

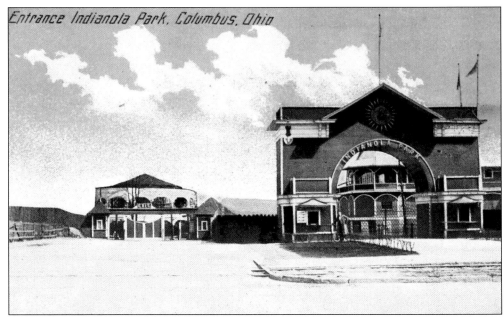

INDIANOLA PARK, ENTRANCE. A second amusement park in Columbus was Indianola Park, located on the east side of Fourth Street at Nineteenth Avenue. The park was opened in 1905 and closed after the 1937 season, although the ballroom and swimming pool remained open for another year or two. While not as large or popular as Olentangy Park, it too was a substantial park. Demolition of the park facilities began in 1947.

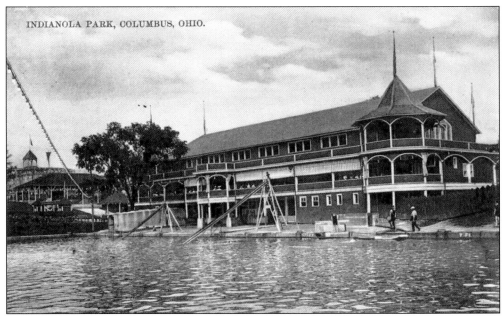

INDIANOLA PARK, BUILDING. The pool at Indianola Park is remembered by some persons as having particularly cold water. The building shown on this postcard was converted into the Ohio Giant Market after the park closed and is still in use.

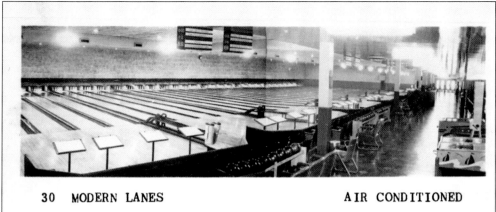

30 MODERN LANES AIR CONDITIONED

RESTAURANT SERVICE FREE PARKING FOR 450 CARS

RIVERVIEW RECREATION, INC.

595 W. GOODALE ST. COLUMBUS, OHIO

RIVERVIEW LANES. The Riverview Lanes bowling alley was opened in 1939 at 595 W. Goodale Street. It was one of the first bowling alleys in Columbus to be air conditioned. Riverview Lanes was equipped with 30 alleys and a restaurant that could seat 100 people.

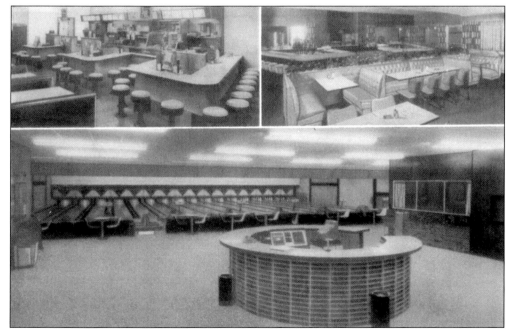

FIESTA LANES. The Fiesta Bowling Lanes was located on Lane Avenue, a little east of N. Star Road. Feista Lanes was a popular bowling spot for residents of northwest Columbus from its opening in 1958 until it closed in 2000. Soon after it closed the building was razed.

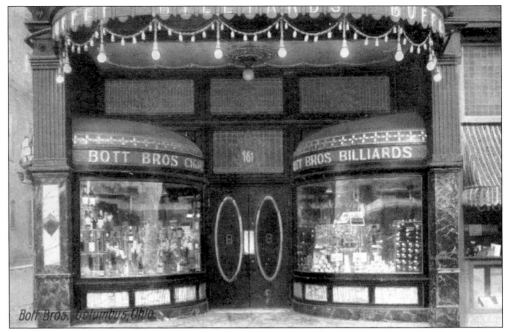

BOTTS BROTHERS EXTERIOR. The Bott Brothers opened a café and billiard hall on S. High Street in 1883. After moving to a N. High Street location, they constructed an elaborate new storefront. When the building in which they were located was demolished in 1905, they moved the entire storefront to a new location at 161 N. High Street, where they operated until 1923. The business became the Clock Restaurant in 1925 and the Elevator Brewery & Draught Haus restaurant in 2000.

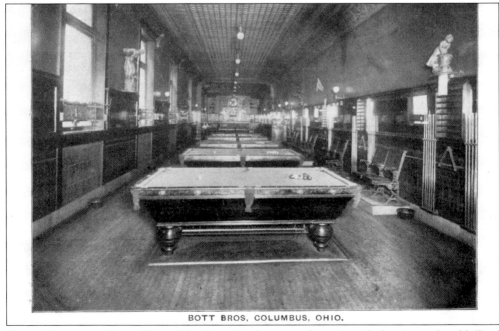

BOTT BROS, COLUMBUS, OHIO.

BOTTS BROTHERS POOL HALL. The Botts Brothers were long-time dealers in pool and billiard tables. The pool and billiard hall on the second floor of their café was the largest in Columbus.

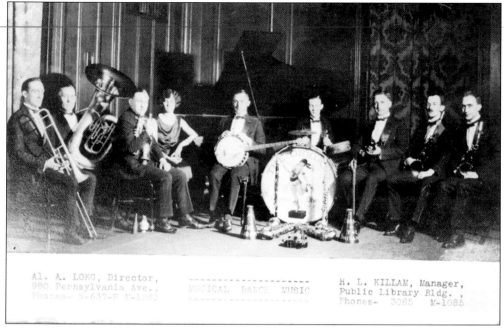

BAND. The Ohioans band offered "musical dance music" about 1910. This was one of the many bands that flourished in the days before radio, records, and CDs, when the only way to have music was from a live band. Alfred A. Long, the band director, is listed in city directories as a stenographer for the Hocking Valley Railroad. Thus, as with most bands at the time, music must have been a part-time occupation.

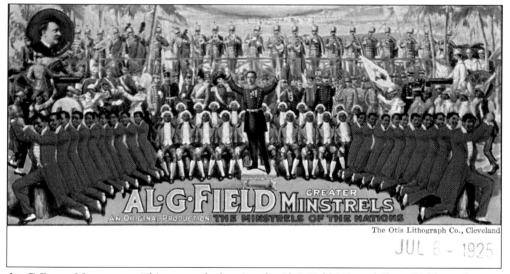

The Otis Lithograph Co., Cleveland

JUL 8 - 1925

AL. G. FIELD MINSTRELS. This postcard advertises the Al. G. Field Minstrel Show. Fields was born as Albert G. Hatfield. He worked as a clown for the Sells Brothers Circus and later, in 1886, he organized what became a nationally known minstrel-show company. His annual minstrel tour opened during State Fair week in Columbus and moved on to the East, South and Midwest. Although Field died in 1920, the show continued, as evidenced by the 1925 date on this postcard.

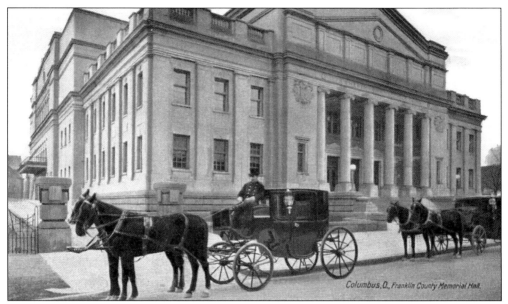

MEMORIAL HALL. The Franklin County Memorial Hall was originally intended to honor Franklin County veterans of the Civil War. However, by the time the money was appropriated, the United States had fought the Spanish-American War, and so veterans of both wars were honored. Memorial Hall was designed by Frank Packard and was completed in 1906. After the new Veteran's Memorial Hall was opened in 1955, the Center of Science and Industry was located in this building from 1961 until 1999. It is presently being refurbished to serve as county offices. It is located at 280 E. Broad Street.

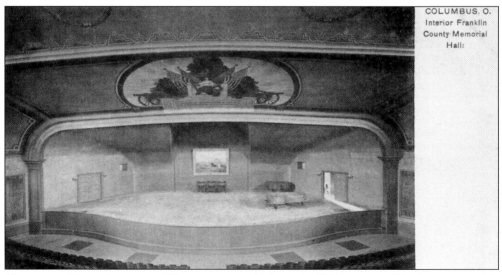

MEMORIAL HALL, INTERIOR. When constructed Memorial Hall was one of the largest assembly halls in the country; it had 4,200 permanent seats and could sit 800 in extra chairs. However, it was always limited because the stage area was too small for many purposes. Among those who spoke or performed here were Teddy Roosevelt, Billy Sunday, Enrico Caruso, Rudolph Valentino and Jack Dempsey. It also hosted high school commencements, poultry shows, Handel's *Messiah*, and wrestling shows.

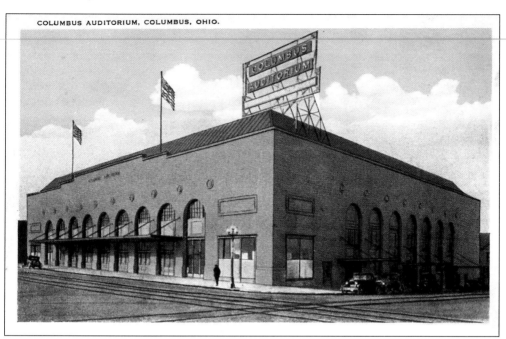

COLUMBUS AUDITORIUM, COLUMBUS, OHIO.

COLUMBUS AUDITORIUM. Although Columbus had the Memorial Hall, many considered its small stage inadequate for opera and ballet, and groups promoting tradeshows and large expositions wanted a larger display area. Thus, in 1927 the Columbus Auditorium was opened on the southwest corner of Town and Front Streets. It housed various entertainment events, including OSU basketball and marathon dances. In 1946 it was acquired by the Lazarus department store and became the Lazarus Annex. It was razed in 1992.

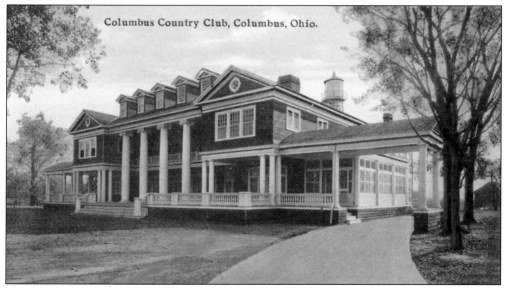

Columbus Country Club, Columbus, Ohio.

COLUMBUS COUNTRY CLUB. The Columbus Country Club opened on E. Broad Street at Big Walnut Creek in 1904. This club house was destroyed by fire in January 1962. However, a new club house was completed in time to host the 1964 Professional Golfers Association (PGA) championship tournament.

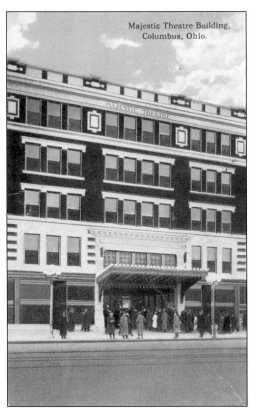

Majestic Theatre Building,
Columbus, Ohio.

MAJESTIC THEATRE, OUTSIDE. The Majestic Theatre, located at 63 S. High St., was opened in 1914. At that time all movies were silent films. When talkies came out in the late 1920s, the management of the Majestic Theatre believed they were only a passing fad and determined to remain a silent movie theater. They did eventually convert to talkies. The Majestic Theatre was extensively remodeled in 1936 and was razed in 1950.

MAJESTIC THEATRE, PROGRAM. While many movie theaters advertised in newspapers, the Majestic Theatre is the only Columbus theater that is known to have advertised by distributing postcards showing its future playbill.

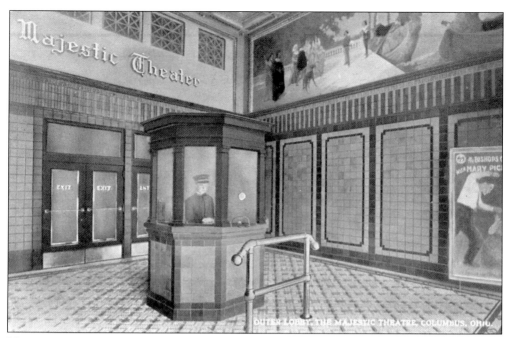

MAJESTIC THEATRE, LOBBY. Even the lobby of the Majestic Theatre was first class. On the side wall of the lobby can be seen a portion of a fresco depicting "The Departure," a Venetian scene. On the opposite wall was a fresco of Napoleon.

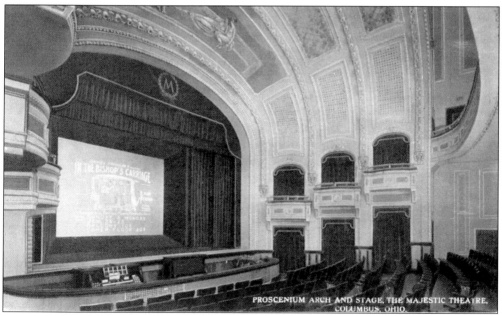

MAJESTIC THEATRE, INSIDE. This inside view of the Majestic Theatre shows the organ and the piano that were used to accompany the silent movies shown at the theater. The Majestic was Columbus's first theater designed exclusively for motion pictures. It had a capacity of 1,200.

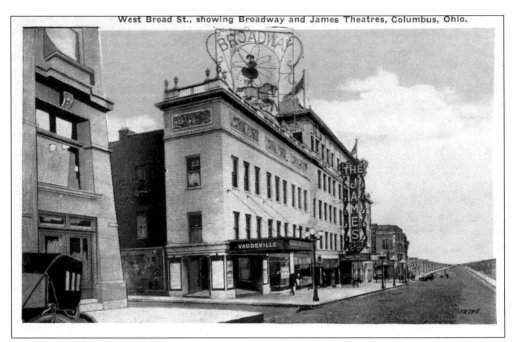

BROADWAY THEATRE. The Broadway Theatre opened in 1911. In the pre-movie days it featured vaudeville, burlesque and musical comedy. An electric sign atop the theater illustrated a dancing girl skipping rope while standing on the back of a horse. The Broadway closed in 1929.

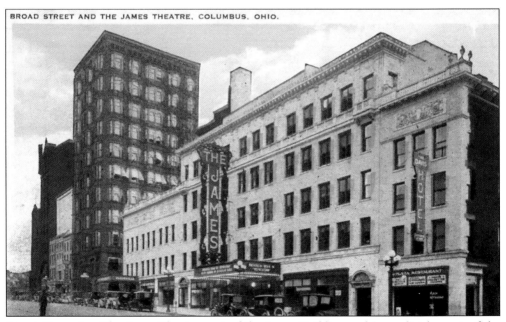

JAMES THEATRE. The James Theatre, part of the James Building and immediately west of the Broadway Theater, was opened in 1921. It was Columbus's first elaborate movie palace and could seat 3,000 persons. The sign in front contained 3,000 flashing bulbs. In 1927 it was acquired by Loew's & United Artists and renamed the Loew's Broad Theater. It was closed in 1961and razed to make space for the Huntington Trust Building.

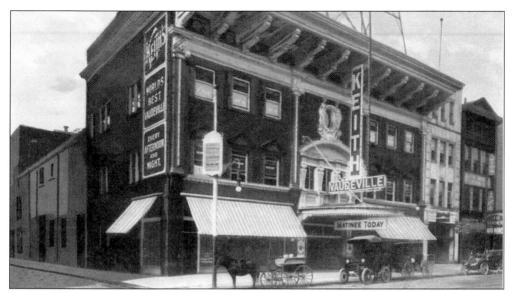

KEITH'S THEATRE. Keith's Theatre was primarily a vaudeville theater and was located on the northeast corner of E. Gay Street and N. Pearl Alley. It opened as the Empire Theatre in 1902 and became Keith's Theatre in 1906. It was closed in 1926 when the new Keith's (later the RKO Palace) Theatre opened in the AIU Citadel (now LeVeque Tower). The Keith Theatre building was razed shortly after the theater closed to clear the space for the Buckeye State Savings and Loan Co. building.

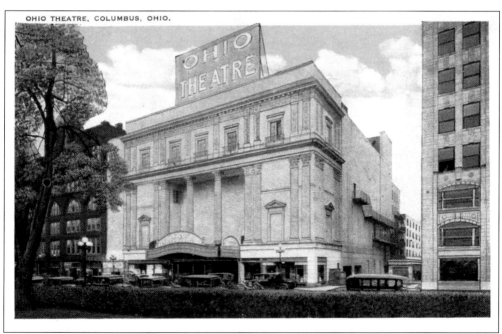

OHIO THEATRE. The Ohio Theatre was built in 1928 on the site of the old city hall (which burned in 1921). The theater was almost razed in 1969. However, a local group formed the Columbus Association for the Performing Arts and raised enough money to purchase the building. Over the next few years it was restored to its 1928 grandeur. It is located at 31 E. State St.

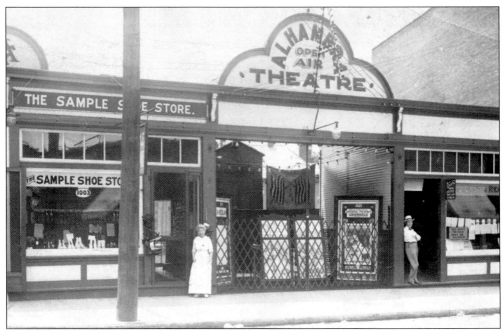

ALHAMBRA THEATRE. The Alhambra Theatre was an open air theater located at 1001 Mt.Vernon Avenue. It operated from 1916 to 1921. It appears to have been a walk-in theater, a predecessor of the drive-in theaters of the 1950s.

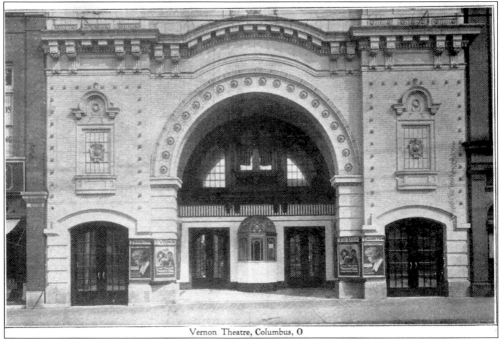

Vernon Theatre, Columbus, O

VERNON THEATRE. A neighbor of the Alhambra Theatre was the Vernon Theatre, located at 1058 Mt.Vernon Avenue. It opened in 1914. In 1928 it was purchased by the Neths theater chain and became the Cameo Theatre. The Cameo closed in 1962.

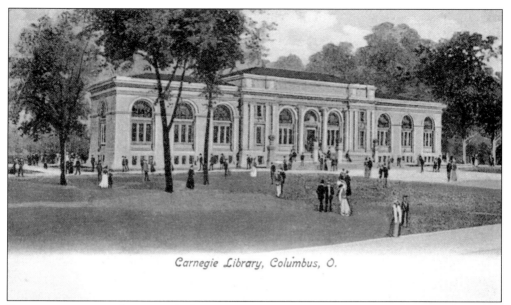

Carnegie Library, Columbus, O.

PUBLIC LIBRARY. The main facility of the Columbus Public (now Metropolitan) Library was Columbus's first building constructed to serve specifically as a library. Built between 1903 and 1906, two-thirds of funding was provided by Andrew Carnegie. The building, located at 96 S. Grant Avenue, served as a temporary city hall from the city hall fire of 1921 until the new city hall opened in 1928. The library underwent extensive remodeling and enlargement in 1991.

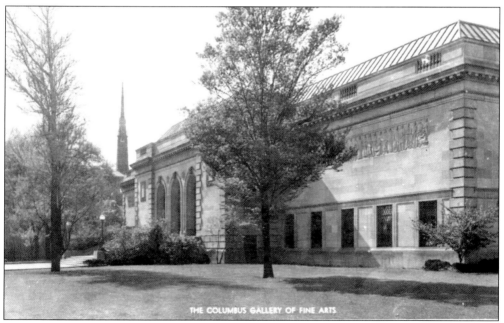

THE COLUMBUS GALLERY OF FINE ARTS

COLUMBUS ART GALLERY. Columbus's first Gallery of Fine Arts was organized in 1878. The Gallery of Fine Arts merged with the Columbus Art Association in 1922 to form the Columbus Gallery of Fine Arts. Finally, in 1931, an Art Gallery was built and opened at 480 E. Broad Street. Today it is known as the Columbus Museum of Art.

103

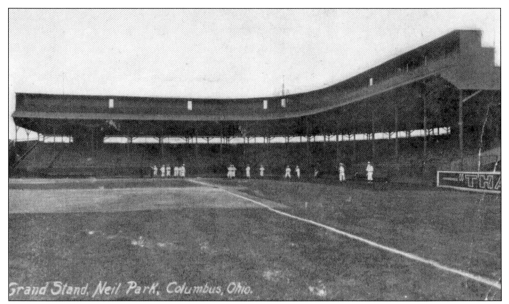

NEIL PARK. Neil Park was a sports stadium that served as the home of Columbus's professional baseball and football teams from 1900 to 1932, as well as hosting college games and other events. It was located on the west side of Cleveland Avenue about one-quarter mile north of Buckingham Avenue. Neil Park was demolished in 1946.

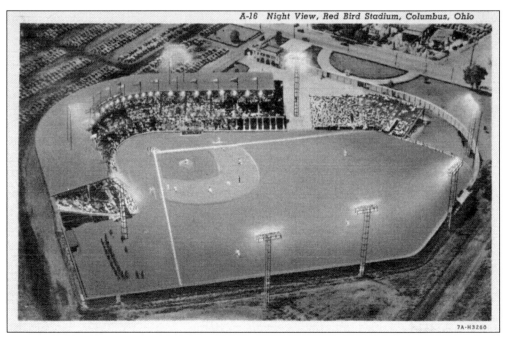

RED BIRD STADIUM. Red Bird Stadium was opened in 1932 as the home for the Columbus Red Birds baseball team. It was long considered one of the finest minor-league ball parks. In succession, it was renamed Jet Stadium, Clipper Stadium, Franklin Co. Stadium, and Cooper Stadium. Located on W. Mound Street at Glenwood Avenue, it was extensively remodeled in 1976 in preparation for minor league baseball returning to Columbus.

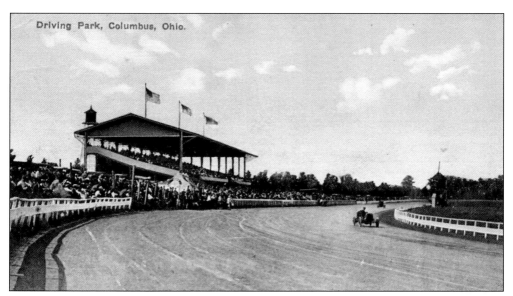

Driving Park, Columbus, Ohio.

DRIVING PARK. The Driving Park in southeast Columbus covered 86 acres and included a one-mile race track. The park was located southeast from the corner of Livingston and Kelton Avenues. Although built in 1892 for harness racing, it also hosted automobile and motorcycle races and other events such as aviation meets. The first automobile racing program in Columbus was held at the Driving Park on July 4, 1903.

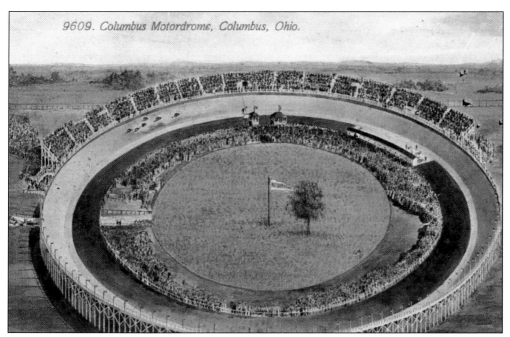

9609. Columbus Motordrome, Columbus, Ohio.

MOTORDROME. The Motordrome was a one-half mile, wooden, above-ground racetrack with a 30-degree banking built in 1912 for motorcycle racing. It has been claimed that it was the first motorcycle race track in the country. The first races were held on July 4, 1913, and were reported to have been attended by 30,000. Reportedly, it was razed in 1913. It was located near Fifth and Cambridge Avenues.

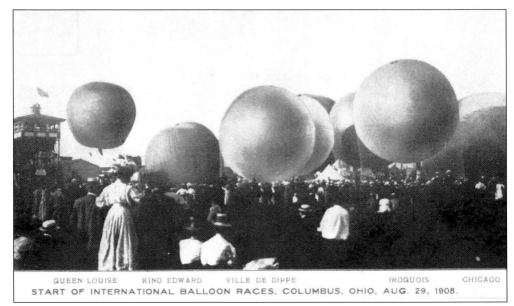

QUEEN LOUISE KING EDWARD VILLE DE DIPPE IROQUOIS CHICAGO
START OF INTERNATIONAL BALLOON RACES, COLUMBUS, OHIO, AUG. 29, 1908.

BALLOON RACE. By 1907 balloon racing was becoming a popular sport. The contest would be to see who could travel the farthest from the launch site before the balloon lost hydrogen and came down. The Driving Park in Columbus was the launch site for a balloon race on August 29, 1908. Six balloons were scheduled to participate in the Columbus race, but only four were actually able to compete. The winner landed in Lake Erie, about 20 miles from Buffalo, New York. Although this postcard purports to show the Columbus race, the photo was actually from an earlier race, probably in Chicago.

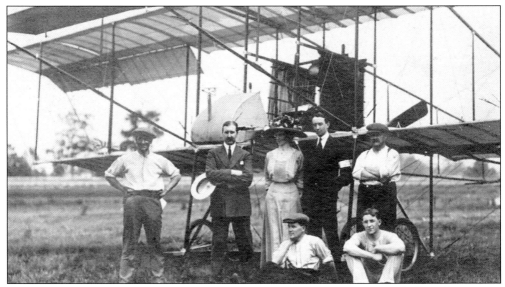

COLUMBUS AIR MEET. From May 29 to June 3, 1911, an aviation meet was held at the Driving Park in Columbus. Six airplanes were scheduled to participate, but three were damaged during a storm, and thus only three actually were able to fly. Contests included fastest takeoff and bomb dropping accuracy. The owner of the airplane pictured, the tall man with the arm band, is Tommy Sopwith, who later became a well-known British aircraft manufacturer.

Eight

HOSPITALS AND INSTITUTIONS

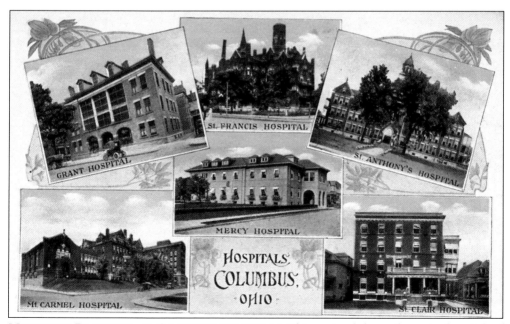

MULTIVIEW POSTCARD OF COLUMBUS HOSPITALS. This postcard shows the major hospitals of Columbus about 1920. Included are Grant Hospital, St. Francis Hospital, St. Anthony's Hospital, Mt. Carmel Hospital, Mercy Hospital, and St. Clair Hospital.

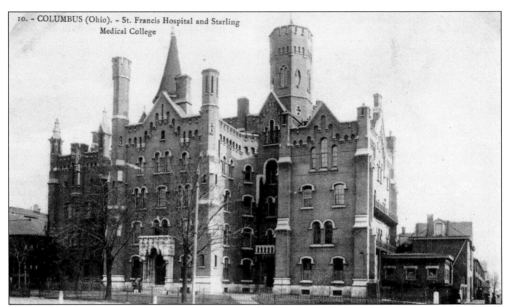

10. - COLUMBUS (Ohio). - St. Francis Hospital and Starling Medical College

ST. FRANCIS HOSPITAL. Construction of the Starling Medical College and hospital on the southeast corner of State and Sixth Streets began in 1849, and the building was ready for occupancy in 1851. It was the first teaching hospital in the United States. In 1865 the Sisters of Poor of St. Francis took over operation of the hospital. The building continued to serve as both the St. Francis Hospital and the Starling Medical School until 1907, when the medial school and the Ohio Medical College merged to form the Starling-Ohio Medical College at another location. This building continued to be operated as a hospital. The building was razed in 1956.

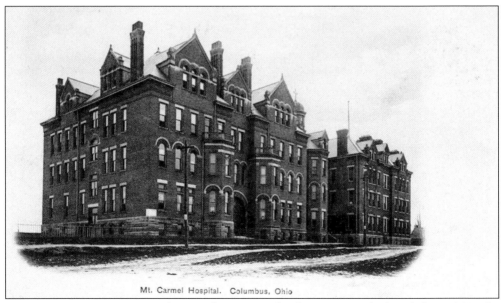

Mt. Carmel Hospital. Columbus, Ohio

MT. CARMEL HOSPITAL. The Hawkes Hospital of Mt. Carmel, founded in 1885 by Dr. W. B. Hawkes, was opened in 1886. By the time of this postcard, there had been an addition (1891) and a second building (1906). Mt. Carmel Hospital has continued to grow and is one of the largest hospitals in Central Ohio.

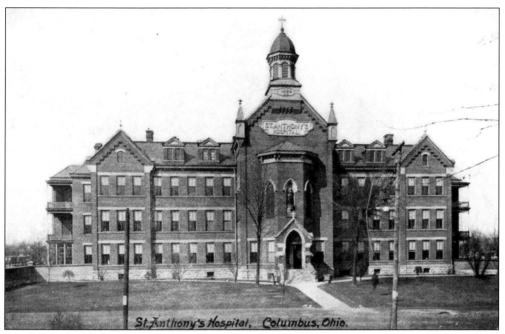

ST. ANTHONY'S HOSPITAL. St. Anthony's Hospital was built in 1891 at Hawthorne and Taylor Avenues. More recently it has operated as the Park Medical Center and since 1999 as the Ohio State University Hospitals East.

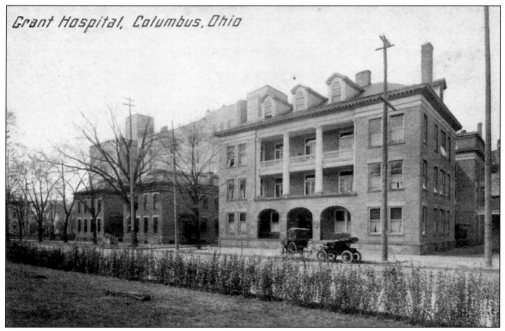

GRANT HOSPITAL. Grant Hospital was opened in 1900 at 125 S. Grant Avenue. Originally built by Dr. J.F. Baldwin to provide care for his private patients, its accommodations were made available to other physicians. Major additions were constructed in 1904 and in 1910.

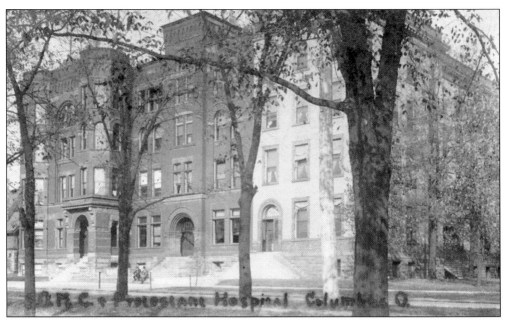

PROTESTANT HOSPITAL. The Protestant Hospital was opened at another site in 1892. In 1894 the building shown above was occupied. Over the years additional facilities were added. Originally operated by the Protestant churches of Columbus, the Methodist church acquired it in 1922. It was located on the east side of Park Avenue, opposite Goodale Park.

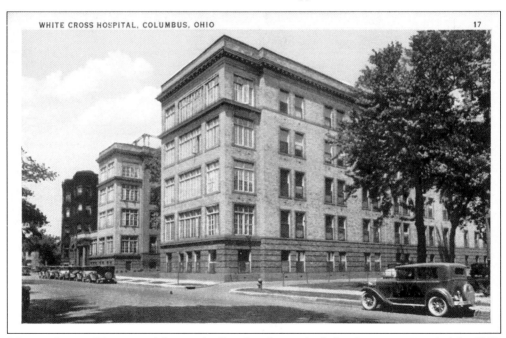

WHITE CROSS HOSPITAL. The Methodist church acquired the Protestant Hospital in 1922. They renamed it White Cross Hospital and dedicated it as such in 1926. When the new Riverside Methodist Hospital opened in 1961, the White Cross Hospital was closed. The buildings were razed a few years later.

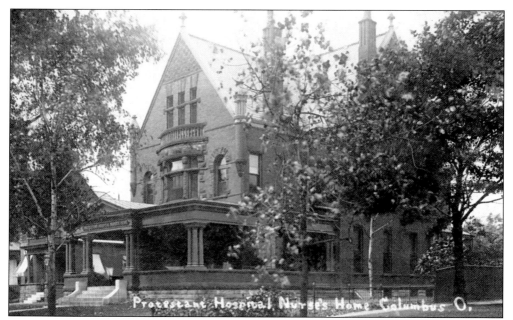

PROTESTANT HOSPITAL NURSE'S HOME. The Protestant Hospital Nurse's Home was located at 98 Buttles Avenue, about one half block north of the hospital. An early 1900s booklet gives the duty hours for those training to be nurses as 7 a.m. to 7 p.m. (or 7 p.m. to 7 a.m.) daily with "a half hour off for meals, two hours time for rest or exercise, and a half day every week." In addition, they had part of Sunday off and three weeks vacation per year. The pupils received board and lodging and, after a three-month probationary period, $5 a month.

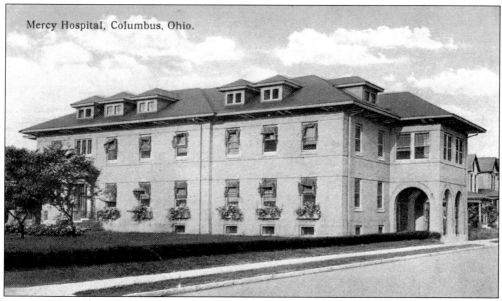

MERCY HOSPITAL. Mercy Hospital opened in 1904 to serve the population on the south side of Columbus. In 1970 new buildings replaced the older building shown on this postcard. Mercy Hospital was renamed Columbus Community Hospital in 2001 and closed later that year for financial reasons. In 2002 it was reopened as an urgent-care facility.

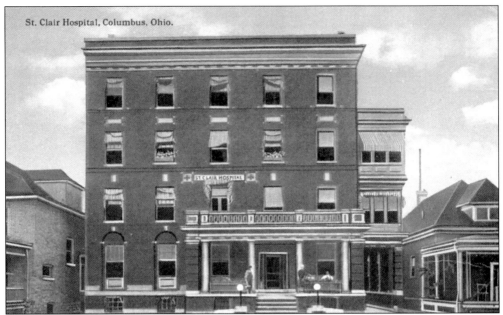

St. Clair Hospital, Columbus, Ohio.

ST. CLAIR HOSPITAL. The St. Clair Hospital opened on January 12, 1911, at 338–344 St. Clair Avenue. A significant number of its clients were the men employed by the Pennsylvania Railroad, which operated a large switchyard nearby. It later became a nursing home, the St. Clair Hotel (1948–1976). Recently, an effort has begun to rehabilitate the building.

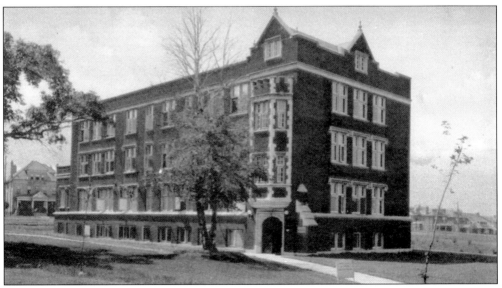

HOMEOPATHIC HOSPITAL. The Ohio State University's medical school dates to 1914, when the trustees of the Starling-Ohio Medical University gave all its properties to establish a College of Medicine at OSU. The first medical building constructed by OSU was the four-story Homeopathic Hospital that was opened in 1916, after OSU assimilated the Cleveland-Pulte Homeopathic College. The College of Homeopathic Medicine was closed in 1922. The Homeopathic Hospital building was incorporated into a larger Starling-Loving Hospital building, which was constructed in 1925.

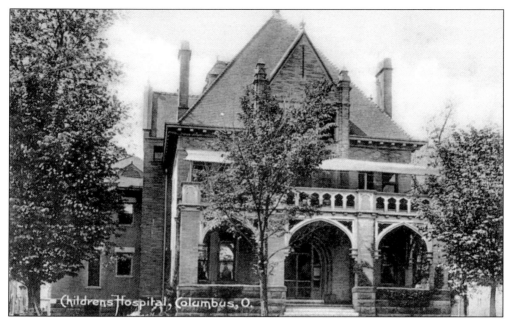

CHILDREN'S HOSPITAL, OLD. The original Children's Hospital opened in 1894 at the corner of Miller and Fair Avenues, across the road from Franklin Park. While still at this location, various groups were organized to generate financial support for Children's Hospital, including the Pleasure Guild (in 1908) and the Twigs (in 1916).

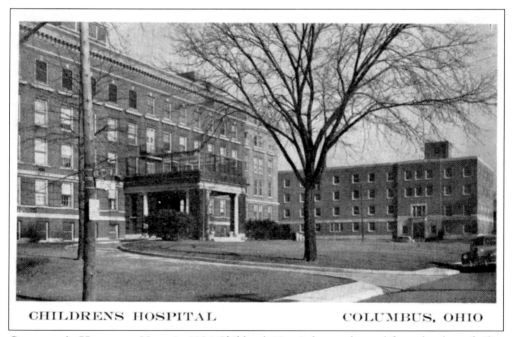

CHILDRENS HOSPITAL COLUMBUS, OHIO

CHILDREN'S HOSPITAL, NEW. In 1924 Children's Hospital was relocated from the above facility to this new building near Livingston Park. The hospital has continued to grow and currently is the major children's hospital for central and southeast Ohio.

BABY CAMP. The Baby Camp was established in 1907 by the Instructive District Nursing Association to permit babies of the poor to enjoy fresh air and better care during the summer. It began with a single tent, but within a few years had acquired permanent hospital buildings in the form of a bungalow and cabins. The Baby Camp was located on the south side of Sullivant Avenue (1725) west of Helen Street. The Baby Camp was closed in 1938.

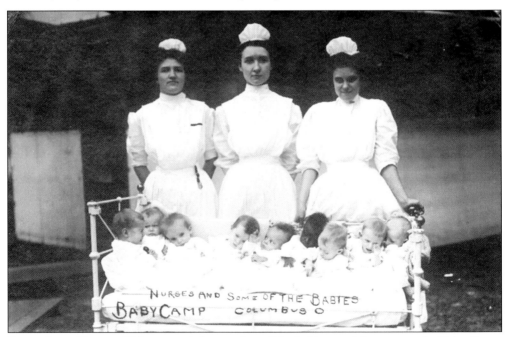

BABY CAMP BABIES. This postcard shows a few of the babies receiving care at the Baby Camp. Presumably, the babies were only crowded into this bed for the purpose of the photograph and they normally had more space. The entire work of the nurses was supported by charitable contributions; the *Columbus Dispatch* provided support to the Baby Camp by soliciting donations.

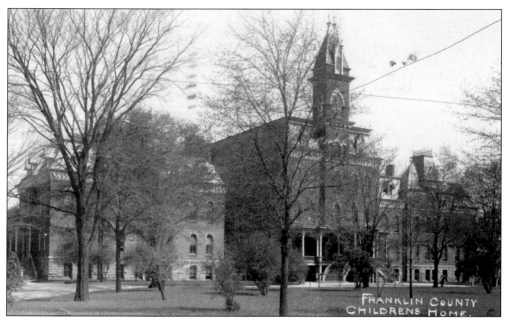

FRANKLIN COUNTY CHILDREN'S HOME. The Franklin County Children's Home was opened in 1880. It was closed when Franklin County Village opened in 1951, and the building was demolished in 1955. The Children's Home was located on the east side of Johnstown Pike just north of Woodland Avenue.

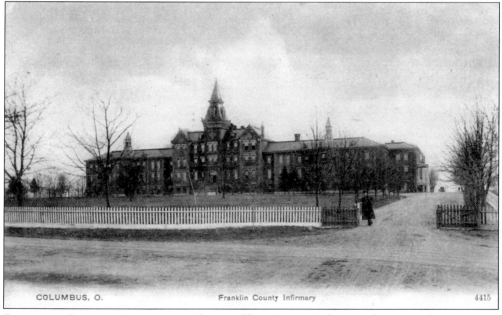

FRANKLIN COUNTY INFIRMARY. The Franklin County Infirmary shown in this view was opened in 1883 on 98 acres along Alum Creek Drive, southeast of Columbus. It was built "to make comfortable provisions for the unfortunate poor, [which] is a duty incumbent on all." The residents helped grow some of their food. This building was used for 85 years, until new cottage buildings were erected in 1968. The old infirmary was then razed.

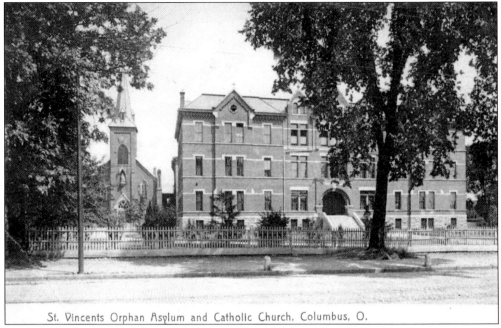

St. Vincents Orphan Asylum and Catholic Church, Columbus, O.

ST. VINCENT ORPHANAGE. The St. Vincent de Paul Orphan Asylum opened in 1875 at 1490 E. Main Street. An addition was constructed in 1894. It closed as an orphanage in 1973 and was then converted into a children's services center. The last nuns left the building in 1994.

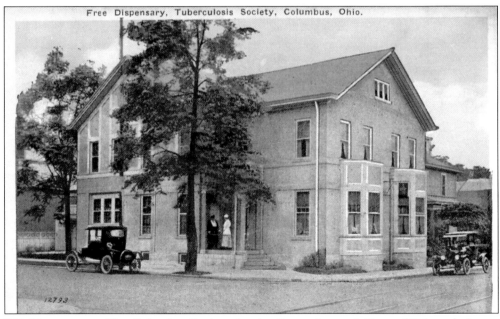

Free Dispensary, Tuberculosis Society, Columbus, Ohio.

TB DISPENSARY. The Columbus Society for the Prevention and Cure of Tuberculosis was organized in 1906. Shortly thereafter, the society opened a free dispensary at 34 E. Rich Street. In 1920, with the aid of funds raised by the Rotary Club, the society purchased a headquarters building on the southwest corner of Washington and Oak Streets and closed the Rich Street dispensary. It is the 1920 building that is shown on this postcard.

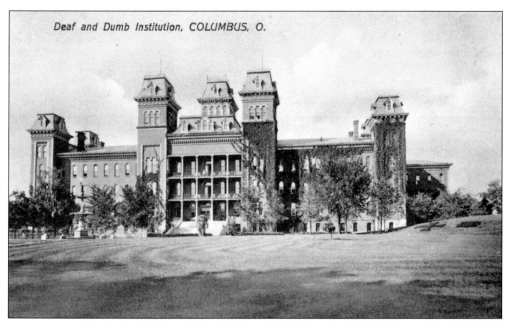

Deaf and Dumb Institution, COLUMBUS, O.

DEAF SCHOOL. This building for the Ohio School for the Deaf and Dumb was completed in 1866. It was closed and the pupils were moved to a new location at 500 Morse Road in 1953. After sitting idle for many years, the building was destroyed by a fire in October of 1981. The deaf school site at 450 E. Town Street is now home to the Topiary Park.

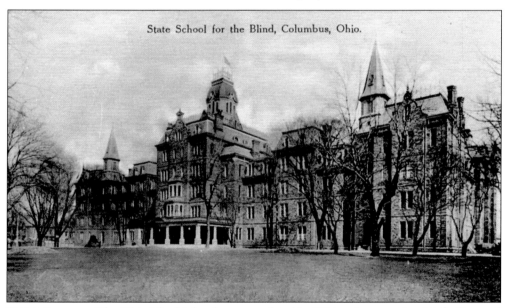

State School for the Blind, Columbus, Ohio.

BLIND SCHOOL. The Ohio Blind School was completed in 1874 and operated at this facility until 1953, when it was closed and the pupils were moved to a new location at 5220 N. High Street. After that, the building was used by the Ohio Highway Patrol for a time and then went unused for a number of years. While being rehabilitated for use by the (Columbus Health Department), it was damaged by fire on January 15, 2001, but repair continued. It is located on the northeast corner of the intersection of Main Street and Parsons Avenue.

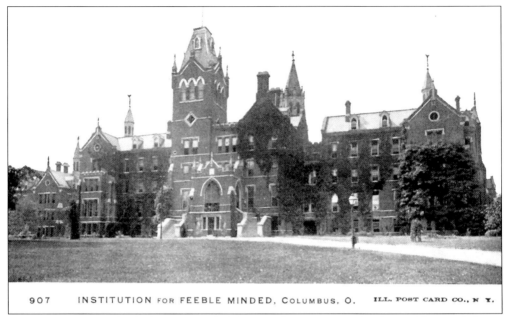

907 INSTITUTION FOR FEEBLE MINDED, COLUMBUS, O. ILL. POST CARD CO., N Y.

FEEBLE MINDED. This building, identified here as the Institution for the Feeble Minded, was completed in 1868. It was a school for mentally retarded children and adults. Other old postcards title it as the "State Institution for the Imbecile" and the "Imbecile Asylum." In 1881 a fire destroyed much of the building, but it was rebuilt. It was later renamed the Columbus State School and, finally, the Columbus Developmental Center. In 1953 the facility included 34 main buildings distributed over 197 acres. It was located at 1601 W. Broad Street and was razed in 1987.

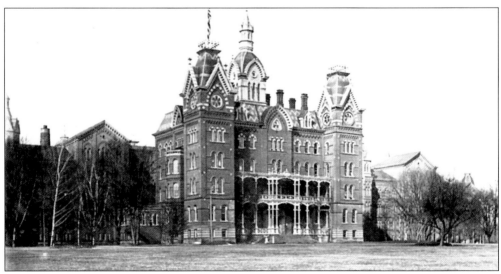

STATE HOSPITAL. This building, identified here as the State Hospital, was built from 1870 to 1877. Other old postcards title it the "Hospital for the Insane" and the "Asylum for the Insane," while other sources refer to it as the "Ohio Hospital for Lunatics." It was later renamed the Columbus State Hospital and, finally, the Central Ohio Psychiatric Hospital. It is claimed that it was the largest building under one roof until the Pentagon was built, as well as being the largest mental hospital in the world. It was located at 1960 W. Broad Street and was razed in 1987.

Nine

MANUFACTURING AND BUSINESS

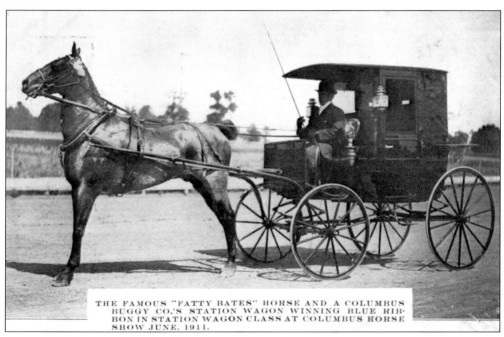

THE FAMOUS "FATTY BATES" HORSE AND A COLUMBUS BUGGY CO.'S STATION WAGON WINNING BLUE RIBBON IN STATION WAGON CLASS AT COLUMBUS HORSE SHOW JUNE, 1911.

COLUMBUS BUGGY. This award-winning buggy was one of over 60 models manufactured by the Columbus Buggy Company. In 1892 it was reported that they employed 1,200 persons and their facilities were capable of manufacturing about 100 vehicles and 1500 carriage dashes per day. Their buggies were shipped all over the United States and were exported "to nearly all the countries of the world."

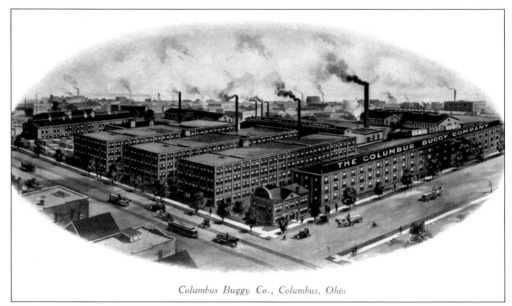

Columbus Buggy Co., Columbus, Ohio

COLUMBUS BUGGY COMPANY. The Columbus Buggy and Peters Dash Company was organized in 1875. It grew to become one of the largest manufacturers of buggies in the U.S. Later the company produced electric and gasoline cars. The plant shown in this postcard was located on the southwest corner of Naghten (now Nationwide Boulevard.) and High Streets. Production was moved to a new plant on Dublin Road in 1904.

ALLEN MOTOR CAR COMPANY. The building shown at the center of this postcard was built by the Columbus Buggy Company in 1902 as a manufacturing plant for buggies and automobiles. When the Allen Motor Car Company moved from Fostoria to Columbus in 1919, they occupied the building for manufacturing their Allen cars until the company failed in 1923. After serving the Janitrol Corp. for many years, it was redeveloped as the Buggy Works in the 1990s. It is located at 400 Dublin Avenue.

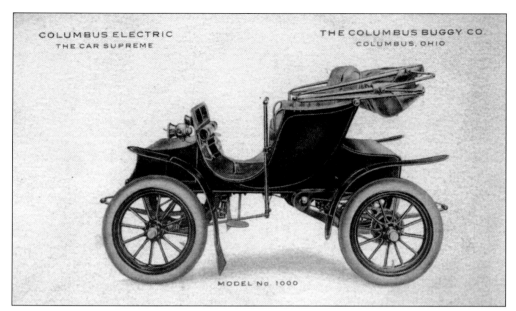

THE COLUMBUS ELECTRIC. The Columbus Electric was the first automobile manufactured by the Columbus Buggy Company. The first Columbus Electrics were manufactured in 1903, and several models were offered. Advertisements cited the ease with which they could be operated (targeting women) and how quietly they operated. The major disadvantage was their speed (20 mph), their limited range, and that it would take hours to recharge the batteries.

FIRESTONE-COLUMBUS. The Firestone-Columbus was a gasoline-powered automobile manufactured by the Columbus Buggy Company. After manufacturing the Buggymobile (literally a powered buggy) for several years, they began manufacturing the Firestone-Columbus in 1909. The failure of the Columbus Buggy Company in 1913 was in part a result of the flood of that year, but probably was at least partly attributable to the competition from the low-cost Model T Ford.

121

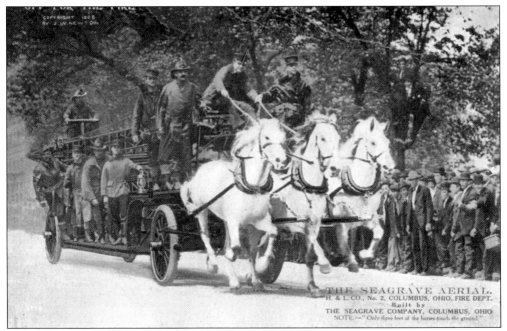

SEAGRAVE HOOK & LADDER. From 1898 to 1964 Columbus was home to the Seagrave Company, a major manufacture of fire-fighting vehicles. This postcard shows a three-horse hook-and-ladder manufactured by Seagrave in 1908 and operated by the Columbus Fire Department. The occasion for this run was likely the fire chief's convention held in Columbus in 1908. Columbus did not complete conversion from horse-drawn to engine-powered vehicles until 1919.

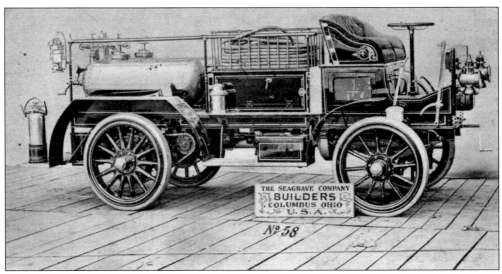

SEAGRAVE MOTOR ENGINE. The Seagrave Company introduced their first engine-powered fire fighting vehicle in 1907. This postcard shows their engine-powered chemical engine, which was displayed at the Fire Engineer's Convention in Columbus in 1908. Features of this vehicle included solid rubber tires and chain drive. Notice that the rear (driving) wheels have more spokes than the front wheels. Seagrave was one of only a few fire engine manufactures to store the hose in a flat roll, rather than on a coil.

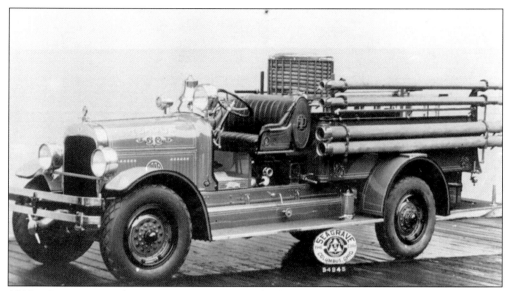

1920s Seagrave. This Seagrave pumper truck dates to the 1925–1930 period. It is one of Seagrave's Suburbanite models, a series of low-priced, lightweight fire engines that were particularly useful in areas with poor roads. This particular engine was built for the Teague (probably Texas) Fire Department.

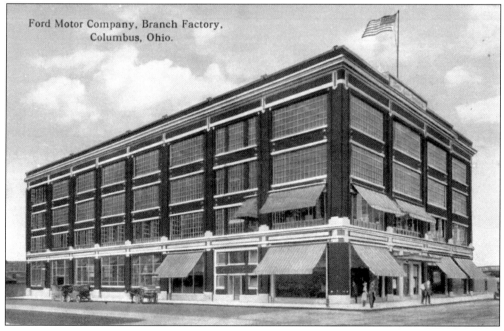

Ford Motor Company, Branch Factory, Columbus, Ohio.

Ford Assembly Plant. Beginning in 1914, Model T Ford automobiles were assembled at the Ford assembly plant on the northwest corner of Cleveland Avenue and Buckingham Street. The components arrived by train, and the automobile were put together at this plant for delivery to local dealers. It is said that the shipping boxes were sized so that the wood from the empty boxes could be used as floorboards for the automobiles. The plant was closed about 1939.

HELLDIVER. In 1941 the Federal government built a plant in Columbus for the purpose of manufacturing airplanes for the anticipated war effort. The plant was leased to the Curtis-Wright Corp. The principal airplane manufactured there during World War II was the SB2C Helldiver, a U.S. Navy dive bomber. Although the Helldiver initially had many problems, it eventually became a successful aircraft.

XP-87. The XP-87 was the first jet aircraft built in Columbus. It was designed and built by the Curtis-Wright Corp. to be an all-weather interceptor. It featured four jet engines and side-by-side seating for the pilot and the radar operator. After being competed in 1947, it was taken to Muroc Air Force Base for trials, where it competed with the Northrup XP-89 and the Lockheed F-94C for Department of Defense contracts. Curtis-Wright lost the competition, which essentially ended their operation in Columbus.

M.C. LILLEY COMPANY. The M.C. Lilley Company was organized about 1865 to publish the *Odd Fellows Companion* for the International Order of Odd Fellows. They later expanded, producing fraternal items for various lodges and societies. The need for more space was solved by constructing this building at 87 N. Sixth Street in 1891–92. In 1897 the company employed 700 persons. However, business began declining during the Depression and the company (then Lilley-Ames) moved from this building in 1950 and ceased operation in 1953. The building was razed in 1973.

LINDENBERG PIANO COMPANY. The Lindenberg Piano Company manufactured player pianos. These pianos played a tune that was punched on a paper roll (much like the punches on computer cards of the 1960s). When the operator worked the foot pedals, the roll advanced and the holes controlled the release of air that caused hammers to strike the keys. Thus, anyone with the energy to work the pedals could play a tune. The Lindenberg Piano Company was located on the northeast corner of W. Buttles and Michigan Avenues.

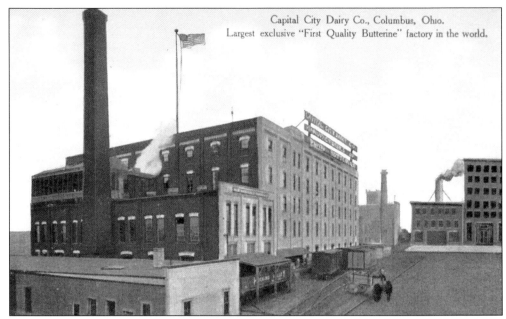

Capital City Dairy Co., Columbus, Ohio.
Largest exclusive "First Quality Butterine" factory in the world.

CAPITAL CITY DAIRY. The Capital City Products Company evolved from the efforts (begun in 1883) of Dennis Kelly, a Columbus grocer, to produce an all-vegetable margarine. The margarine he produced was marketed as Purity Butterine. The company was organized as the Capital City Dairy about 1892, became the Capital City Products in 1919, and was purchased by AC Humko in 1996. The plant was closed in April 2001.

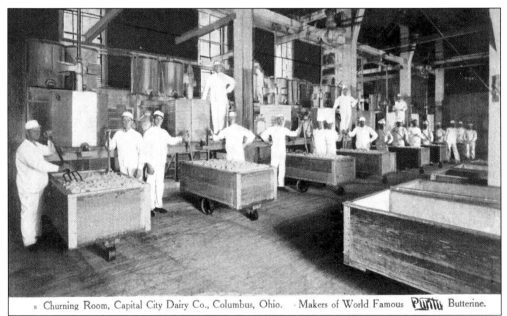

Churning Room, Capital City Dairy Co., Columbus, Ohio. · Makers of World Famous Purity Butterine.

CAPITAL CITY DAIRY, INTERIOR. For many years there was a battle in the Ohio State Legislature over whether margarine could be colored. The best argument of the margarine manufacturers was that butter was colored ten months of the year. Eventually colored margarine was allowed.

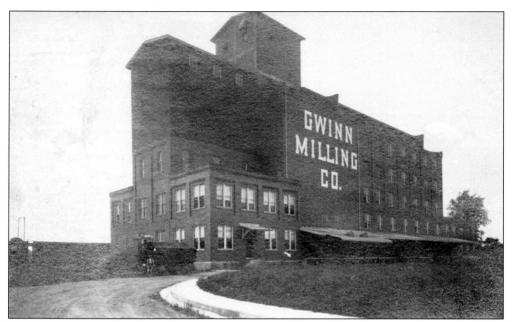

GWINN MILLING COMPANY. The Gwinn Milling Company's grain elevators opened in 1909 at 1915 E. Main Street. Several serious fires resulted from explosions of the grain dust associated with handling the grain—in 1945, 1947, and 1949. The Gwinn Milling Company ceased operation in 1950, and the facility was sold to the Continental Grain Company.

FELBER BISCUIT COMPANY. Among the products made by the Felber Biscuit Company was Pennant Crackers. The back of the postcard invites persons to "Now come to see these cracker-cakes, in process so refined. Then you, as we, will tell your friends to use no other kind." The plant was located at 392 N. Grant Avenue, at the northeast corner of McCoy. Founded in 1866 as a bakery, Felber was purchased by the Keebler Company in 1953.

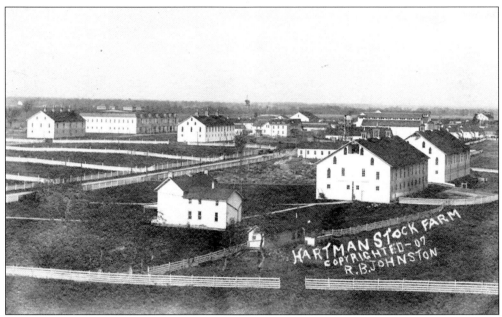

HARTMAN FARM BUILDINGS. In 1903 Dr. Samuel B. Hartman, of Peruna fame, began accumulating the property and constructing the buildings of what became the Hartman Farm. Eventually the farm consisted of 4,000 acres. Besides crops, the farm included horses, cows, ducks, etc., and orchards. It occupied both sides of Route 23 south of Columbus. After Dr. Hartman died, the farm continued to be operated by a trust. Eventually the trust closed the farm and sold the land.

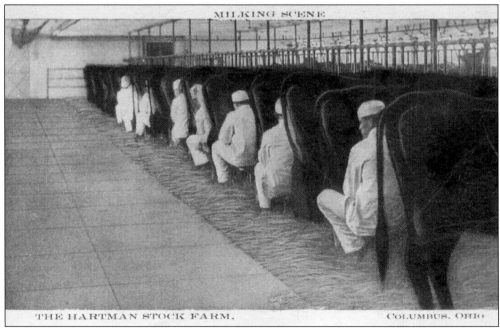

HARTMAN FARM DAIRY BARN. Among the products of the Hartman Farm was milk. This postcard shows a milking scene. Hartman Farm milk bottles are sought by collectors.